AROUND THE WORLD IN 80 DAYS

—————————————————•—————————————————

A RIDE THROUGH THE GREATEST CYCLING STORIES

Giles Belbin is a freelance writer with a focus on cycling. His work has been published in Procyling, *Cycling Weekly, Australia's Ride Cycling Review*, the *Independent* and *Guardian* online. Giles reported on all of the cycling events at London 2012 for the Olympic News Service. His first cycling book, *Mountain Kings,* was published in 2013.

Daniel Seex has been a professional illustrator for over three years and has worked for a number of high-profile clients including Google, Channel 4, Johnnie Walker and Chivas Regal and for cycling publications *The Ride Journal* and *Boneshaker*. Daniel works primarily in pen and ink, adding colour and texture digitally and often building a picture from multiple drawings. He lives in Vienna with his partner Julia.

www.thejoyofseex.co.uk

AROUND THE WORLD IN 80 DAYS

·

A RIDE THROUGH THE GREATEST CYCLING STORIES

Written by Giles Belbin
Illustrated by Daniel Seex

Aurum
Press

Quarto is the authority on a wide range of topics.
Quarto educates, entertains and enriches the lives of
our readers— enthusiasts and lovers of hands-on living.
www.QuartoKnows.com

First published in Great Britain
2017 by Aurum Press Ltd
74–77 White Lion Street
Islington
London N1 9PF
www.quartoknows.com

A catalogue record for this book is available from the British Library.

ISBN 978 1 78131 656 6
eBook ISBN 978 1 78131 687 0

10 9 8 7 6 5 4 3 2 1
2021 2020 2019 2018 2017

Interior design by: Neal Cobourne
Printed in China

CONTENTS

1

The death of Fausto Coppi
(2 January 1960)

Fausto Coppi remains one of cycling's greatest ever riders. He rode with grace and panache, a silky, smooth pedalling action belying the effort he put into propelling his machine. His appeal was best summed up by fellow rider André Leducq, who described Coppi as riding like 'a great artist painting a water colour'.

Coppi was born in 1919, in Castellania, north-west Italy. He developed his cycling legs early in life, working as a delivery boy for a butcher. His first race win came in 1938 in the Castelletto d'Orba-Alessandria. His breakthrough year was 1940, with a national title on the track, followed by a stage win and the overall victory in the Giro d'Italia; the first of five wins in Italy's national tour.

Despite losing some of his prime years to the Second World War, Coppi's *palmarès* (list of races won) place him at the top table of cycling's greats. Coppi won the Tour de France twice; holds the record for most wins in the Tour of Lombardy; won Milan–Sanremo three times; and became world champion in 1953. He also held the hour record from 1942 until 1956.

Away from the bike his life was beset by tragedy. Fausto's younger brother Serse died in 1951, after falling while sprinting to the finish line of the Giro del Piemonte. Later, Coppi faced the wrath of the Catholic Church for his affair with Giulia Occhini.

In December 1959, having retired earlier that year, Coppi travelled to Upper Volta in Africa for an exhibition race. He returned complaining of feeling unwell and was diagnosed as having pneumonia. In fact, he had contracted malaria. Coppi died on the morning of 2 January 1960. Ten thousand mourners attended his funeral.

2

Thomas Stevens cycles round the world
(4 January 1887)

San Francisco. Four days into 1887 and a steamer arrives in port. It had set out some 17 days earlier from Yokohama, Japan. On board was Thomas Stevens. Among his belongings was a penny-farthing.

Stevens was an Englishman who had moved to the United States. Living in California, the adventurer within got the better of him and he hatched a plan to cycle across America. He departed from San Francisco on 22 April 1884 and rode to Boston.

But that wasn't enough for Stevens. Encouraged by *Outing* magazine, on he went. After taking a ship to Liverpool, Stevens rode through Europe and into Asia. There he cycled across India before travelling to Singapore and on to Hong Kong. After traversing the southern reaches of China, he finally reached Japan to record the first bike ride around the world. It had been 13,500-miles (22,000km) and over three and a half years since he'd left San Francisco. Described as an 'impracticable scheme of a visionary', his dream had been realised.

Stevens documented his travels in his two-volume book *Around the World on a Bicycle*, in the preface to which Thomas Higginson of the Massachusetts Bicycle Club writes: '[We find] modern mechanical invention [the bicycle], instead of disenchanting the universe, had really afforded the means of exploring its marvels the more surely. Instead of going round the world with a rifle, for the purpose of killing something – or with a bundle of tracts, in order to convert somebody – this bold youth simply went round the globe to see the people who were on it; and since he always had something to show them as interesting as anything that they could show him, he made his way among all nations.'

3

Jacques Anquetil is born
(8 January 1934)

Maître Jacques dominated cycling for over 10 years. From the late 1950s through to the mid-sixties he was the patron of the peloton. During that period he became the first man to win five Tours (1957, 1961, 1962, 1963, 1964), and the first to win all three Grand Tours, having also won the Giro (1960, 1964) and the Vuelta (1963).

Anquetil was born in in Mont-Saint-Aignan, near Rouen in northern France, where his parents owned strawberry fields. He entered his first race at the age of 18 and won – the start of a pattern that soon would be often repeated. He came to national prominence at the 1953 GP des Nations when he won the first of nine titles. One month earlier he had won as a virtual unknown at Paris–Normandie, beating the field by over nine minutes. The press were stunned, writing 'who can resist the young Anquetil?' Anquetil's first tour win came in 1957, a tough year and one that saw more established riders either fail to start or abandon. It was Anquetil's first entry in the race and he took the yellow jersey on stage five. He lost it two days later but reclaimed it on stage 10, holding it to Paris.

His most dominant Tour performance came in 1961. Anquetil claimed the first afternoon's time trial to steal the race lead from André Darrigade and end day one in yellow. And that was exactly how he finished the final stage, 21 days and 2,630-miles (4,232km) later in Paris, with no one having been able to wrest it from him for even a single day.

Anquetil won races but never the affections of his public. He was victorious not because of daring escapades but because of careful plotting. It was hugely effective. But it was also cold, calculated and methodical, slap-bang in the middle of arguably cycling's most romantic era.

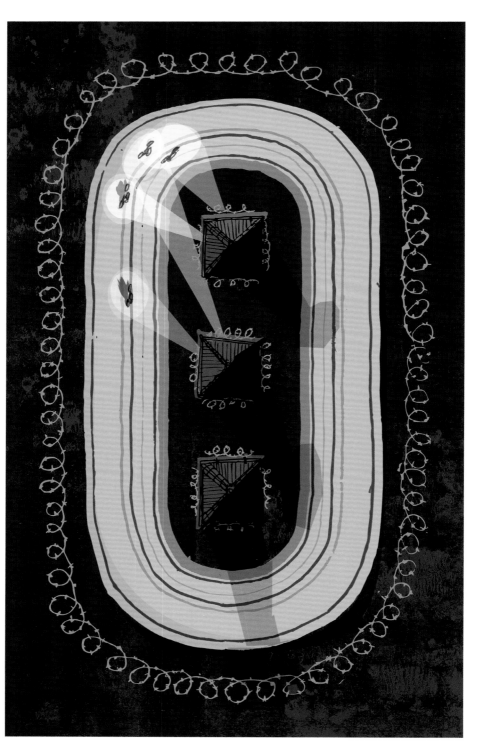

4

The Vélodrome d'Hiver hosts its first six-day race
(13 January 1913)

Affectionately known as the Vél d'Hiv, Paris's Vélodrome d'Hiver (Winter Velodrome) hosted its first six-day race in 1913. The velodrome's origins lie in the Galerie des Machines, a building that had been constructed for the 1889 World Fair near the Eiffel Tower. In 1902, on the orders of Henri Desgrange, a 364-yard (333m) track was first installed and used for racing. Seven years later, when the building was listed for demolition, Desgrange built a new velodrome with a distinctive glass roof. The track was moved, shortened to 273-yards (250m) and renamed the Vélodrome d'Hiver.

By 1913 six-day races, initially founded in Britain but then popularised in America, had begun to gain Europe's interest. The races, in which riders ride in pairs and try to cover as great a distance as possible in six days, attracted huge crowds. On 13 January 1913, the Vél d'Hiv hosted Paris's first six-day event.

That first race was won by Alf Goullet and Joseph Fogler, an Australian and an American respectively, who covered 4,467.58km, beating the French pair Victor Dupré and Octave Lapize into second place.

The event grew into one of the most sought-after tickets in town, the combination of athletic endeavour, alcohol and music inspiring writers, photographers and artists to document their work. In his book *A Moveable Feast*, Ernest Hemingway writes of the 'smoky light of the afternoon and the high-banked wooden track and the whirring sound on the wood as the riders passed… each one a part of his machine.' The Vél d'Hiv continued to host six-day racing until 1958, when French stars Jacques Anquetil and André Darrigade won the final event.

In 1959 fire broke out in the Vél d'Hiv, after which the building was demolished.

5

The inaugural Tour Down Under
(19 January 1999)

Before 1999, Australia did not have its own tour. That changed thanks, at least in part, to Formula One.

Until 1995 the South Australian city of Adelaide was home to the Australian F1 Grand Prix. When Melbourne stole the race from Adelaide, the city was determined to find a replacement to bolster its international standing, hence the creation of the Tour Down Under.

With heavy backing from the region's governing body, Adelaide lobbied the UCI and in 1999 they were rewarded with a slot in the racing calendar.

The inaugural race was a six-stage affair. All stages finished in a bunch sprint apart from stage three, won in a breakaway by Stuart O'Grady. His five-second win over his three fellow escapees was enough to ensure overall victory three days later, a feat he would repeat in 2001.

The record for most wins now belongs to Simon Gerrans. Gerrans, a Melbourne-born winner of both Milan–Sanremo and Liege–Bastogne–Liege, and of stages in all three Grand Tours, has won the race four times (2006, 2012, 2014 and 2016). No rider has ever been able to successfully defend their title.

6

Tom Boonen's Qatar dominance begins
(30 January 2006)

From the mid-2000s, Belgium's Tom Boonen has been one of the world's best one-day classic riders. While he has also claimed a world championship title (2005) and the green jersey at the Tour de France (2007), Tornado Tom earned his nickname for his performances at the Tour of Flanders and Paris–Roubaix – races for which at the time of writing Boonen shares the record for most wins (four at Paris–Roubaix shared with Roger De Vlaeminck; three at Flanders shared with five others). But Boonen has enjoyed early-season success away from one-day Northern European classics as well.

To say the Tour of Qatar has been a happy hunting ground for Boonen is to understate his dominance of an event that first appeared on the calendar in 2002. Boonen moved to the Quick Step team in 2003 and has been with the various incarnations of that set-up ever since. In 2004 he took his first significant wins, claiming E3 Prijs Harelbeke, Ghent–Wevelgem and a couple of Tour stages. Then, in 2005, took his first Flanders/Roubaix double, a feat he repeated in 2012.

Boonen's first stage win in Qatar came in 2004. That was followed with two more in 2005, but it was in 2006 that he really took a stranglehold on the race. Over the course of the five-stage 510-mile- (820km) long race, Boonen won four stages and the overall.

The Belgian went one better in 2007, winning five stages, including stage one's team time trial. His team-mate Wilfried Cretskens won the overall, but Boonen returned to the top of the podium in 2008, 2009 and again in 2012. His haul of four wins is currently a record.

As of 2016 he also holds the record for most stage victories, with 24 to his name (two being team time trials). To put that in perspective, the next best is Mark Cavendish with nine.

7

Nairo Quintana is born
(4 February 1990)

Colombia's latest cycling superstar, Nairo Quintana became only the second Colombian to win a Grand Tour when he won the 2014 Giro d'Italia, following Luis Herrera's 1987 win in the Vuelta. It was Quintana's first ride in Italy's national tour and he dominated the final, crucial week. He took the pink jersey after stage 16, a 86-mile (139km) dance through the Alps that took in the mighty climbs of the Gavia, Stelvio and a final 14-mile (22km) slog up to Val Martello in snow and ice, and he cemented it three days later taking victory in the mountain time trial to Cima Grappa, opening a three-minute advantage overall.

Quintana stood in pink in Milan, showered in golden ticker-tape and holding the giant trophy awarded to the winner of the Giro. He may have been just 24 years old and riding just his third Grand Tour but his win was no surprise, such had been his early promise.

Born into a peasant family in the Boyacá Department of Colombia, Quintana honed his cycling legs over a distance of 10 miles (16km) to school. By 2010 he was in Europe racing at the Tour de l'Avenir. Quintana won two stages and the overall at the race dubbed the Tour of the Future. He was on his way.

In July 2013 he headed to the Tour de France. It was only his second three-week race (he'd finished thirty-sixth at the Vuelta in 2012). He was a sensation. He won a stage, finished second overall, won the King of the Mountains and the white jersey as best young rider. It was the best performance at the Tour by a Colombian, eclipsing Fabio Parra's third place in 1988.

Then came that Giro d'Italia win followed by a further second-placed finish behind Chris Froome at the Tour in 2015. It is surely only the start of what promises to be one of the most exciting cycling careers.

8

The Boston Cycling Club is formed
(11 February 1878)

Holding a special place in the history of cycling in the USA, the Boston Cycling Club was the first of its kind to be formed in the USA. The state of Massachusetts grasped the joys of riding on two wheels before most other states and the Boston Cycling Club was at the forefront of the sport's development. The first mass 100-mile (160km) ride, the first bike race, the first tricycle race, the first 100-mile race, the first hill climb – they all came courtesy of the Boston Cycling Club.

Cycling clubs started springing up all over the United States – Buffalo in 1879, New York 1880. Often these developed along ethnic lines with clubs forming in New York for Italian, German, Belgian and Irish immigrants as well as for Mongolians and Norsemen – reportedly 'limited to the sons and daughters of Harold the Fairhaired'.

The clubs not only provided company for riding but also became a part of society. Some found work for their members, others offered distractions beyond cycling. An article published by *The New York Times* in 1895 that profiled the Cycling Club of Brooklyn described a club that attracted the 'prettiest and most charming of all Brooklyn's pretty and charming young women; the best of her young men; the most esteemed heads of families and attractive matrons'. The article put the club's popularity down to its regular costume rides and teas and 'because of its nice little merry-go-round organ, to the music of whose tuneful airs its members swing gaily around the ring morning, noon, and night'.

9

Marco Pantani dies
(14 February 2004)

Described after his death by Lance Armstrong as 'more of an artist than an athlete', Marco Pantani was a gifted climber who scaled cycling's greatest heights for an all too brief period. Talented yet troubled, Pantani died in a hotel in an out-of-season Rimini on Valentine's Day. The coroner would later record a verdict of 'acute intoxication from cocaine', although in 2014 the cyclist's family would be successful in requesting the inquiry be reopened. At the time of writing investigations continue.

Yet for one so gifted, his *palmarès* is shockingly brief. One Giro. One Tour. Both in 1998. That's it. Finito. He was susceptible to misfortune and suffered a number of horrible crashes that lost him many a season. Later, allegations of doping would come. In pink and two days from Milan, he would be thrown off the Giro in 1999 for failing a 'health check' as his haematocrit level breached 50 per cent (raised haematocrit being an indication of EPO use). His Tour win came in a race hit by the Festina affair. The race was rocked by police raids and rider protests following the discovery of doping products in the car of Willy Voet, an employee of the Festina team. The entire race was in jeopardy. But on the rocky road to Paris, Pantani ignited the Tour. On stage 15 the Italian danced his way up the Alps on a day of tumbling temperatures and drenching rain to slip yellow on for the first time and wear it all the way to Paris.

In an era when racing was increasingly becoming controlled and numbers-driven, Pantani rode with feeling. He didn't wear a heart monitor or measure wattage. Whether it was his back-to-back stage wins in the Dolomites in the 1994 Giro, or that ride to Les Deux Alpes, Pantani always won with panache, sculpting legendary tales from the mountains of the Tour and Giro.

10

Romain Maes dies
(22 February 1983)

Small but strong, Romain Maes rode professionally from 1933 until the outbreak of the Second World War effectively ended his career.

Maes stunned the cycling world when he won the Tour in 1935. And it wasn't just any old win: he did something that only four men have achieved (Garin, 1903, Thys, 1914, Bottecchia, 1924 and Frantz, 1928) – he held the race lead from the first stage to the last.

Maes had done little to show he was a Tour contender. He'd ridden the race just once before, abandoning on stage 10. His best result was one Paris–Nice stage win. But on the Tour's opening stage he escaped the peloton and rode into Lille alone, 53 seconds ahead of the others, after the rest of the race was held up by a closed railway crossing.

Described by Henri Desgrange as a 'ball of muscle', Maes set to defending his lead. He survived a number of scares and mechanicals that threatened his lead, his Belgian team now working for their unlikely leader. A sprinter rather than a climber, most expected him to falter in the mountains. Not so. He emerged from the Alps with three minutes' advantage. In the final week he got even stronger, increasing his lead and winning the final stage in Paris. Come the end, his overall margin was nearly 18 minutes.

According to Pierre Chany, the Belgian sportswriter Théo Mathy said Maes lived on his nerves, writing: 'He is like an electric battery that charges and empties quickly: he is the champion of all or nothing.'

Maes never finished the Tour again. In 1936 he crossed the line of Paris–Roubaix first but was mistakenly awarded second place, the commissaires erroneously judging Georges Speicher to have won the sprint.

He died in 1983 aged 70.

11

Djamolidine Abdoujaparov is born
(28 February 1964)

Nicknamed the Tashkent Terror, Djamolidine Abdoujaparov from Uzbekistan claimed stage wins and three green jerseys at the Tour, as well as stages and the points competitions at the Giro and the Vuelta. A sprinter who duked it out with the toughest in the peloton, to put it kindly his style was unconventional. More than once riders complained he was a danger; that he was an accident waiting to happen.

And an accident was exactly what did happen.

Going into the final stage of the 1991 Tour, Abdoujaparov was leading the points classification. He had ridden the race for the first time the previous year, finishing 145th overall but securing a fourth-placed finish on the Champs-Elysées. This year had been different. He had two stage wins to his name and the green jersey on his back. He couldn't be caught. He only had to finish the race to secure his first points win.

But the final stage of the Tour, when the world watches the riders race on the Champs-Elysées, is one of the biggest days in cycling. And after narrowly missing out the year before, Abdoujaparov wanted the win. As the stage entered its closing moments, with the excitement at fever pitch, the Tashkent Terror was ready to go into battle.

The sprint wound up. Abdoujaparov, head down, legs pumping, was close to the barrier. Too close as it turned out. Fully focused on going for the win, he clipped a railing and was propelled over the handlebars. It was a spectacular high-speed crash that brought down at least two others. Abdoujaparov broke a collarbone and was badly concussed. More than 15 minutes later he was helped across the finish line. Then, instead of standing on the podium in green, he was put straight in an ambulance and whisked off to hospital.

12

Maurice Garin is born
(3 March 1871)

His name now enshrined in cycling history as the first winner of the Tour, Maurice Garin was born in Arvier in north-west Italy in 1871. His was a large family. He had four sisters and four brothers, and life in Italy was tough. So tough, in fact, that his parents decided to move to France when Maurice was 14. By the 1890s Garin was sweeping chimneys in northern France (he would bear the nickname the Chimney Sweep throughout his cycling career). In 1893 he recorded his first race win at Dinan and turned professional the following year.

While Garin's list of wins is not particularly lengthy, what it lacks in quantity it makes up for in quality. In 1897 he claimed the first of two Paris–Roubaix wins. In 1901 he won the second edition of Paris–Brest–Paris. One year later he finally claimed Bordeaux–Paris. By the time of the first Tour, Garin was firmly in place as one of the world's best long-distance racers. He won the first stage – 290-miles (467km) from Paris to Lyons – taking the overall lead and keeping it until he rode back into Paris 18 days later with more than 1,490-miles (2,400km) under his wheels. In total he won three stages and the race by over two hours.

Roundly celebrated as the Tour's first ever winner, Garin's relationship with the race soured in 1904 when he was disqualified, having provisionally been awarded the win. With huge rewards on offer, cheating was rife. Riders slipstreamed behind cars, took the train or accepted lifts, and partisan supporters blockaded roads.

After three weeks of mayhem Garin was the winner. But Desgrange and the Union Vélocipédique de France (UVF) were unhappy. Desgrange announced that the second Tour would be the last – 'killed by its own success'. After months of unravelling, the UVF disqualified 28 riders including Garin and awarded the win to Henri Cornet.

13

First Tirenno–Adriatico starts
(11 March 1966)

Despite coming early in the season, this one-week stage race attracts the biggest stars in road racing. Over the past few years Vincenzo Nibali, Chris Froome, Alberto Contador and Nairo Quintana, all recent Grand Tour winners, have stood on the final podium. Quintana's win, constructed in the snow on the climb to Terminillo – a 16km slog averaging over 7%, with stretches at 12% – came in the race's fiftieth edition, the first time an American had won.

In 1965 Italy's cycling authorities had a problem. Their biggest one-day race, Milan–Sanremo, was being dominated by foreign riders; no Italian rider had won since Loretto Petrucci in 1953. When Arie Den Hartog of the Netherlands won in 1965, outsprinting Italy's Vittorio Adorni and Franco Balmanion on the line, enough was enough. Something needed to be done.

Part of the reason was thought to be Paris–Nice. Milan–Sanremo is the longest of the five major classics and Paris–Nice offered plenty of racing kilometres into the legs in the build-up to the race. From 1953 until 1965, just over half of the riders who had placed on the podium at Sanremo had finished in the top-ten or won a stage of Paris–Nice. It was hard for Italians to get to the race to the sun as Milan–Turin often clashed or took place only a day or so before. A solution was needed in Italy. And so Tirenno–Adriatico was born.

Known as the Race of the Two Seas, it starts on the coast of the Tyrrhenian Sea, travels inland over the spine of Italy and finishes on the Adriatic coast at San Benedetto del Tronto. Featuring time trials, climbing, sprint finishes and at least one long, rolling day, the race today has a little something for everyone. The winner also receives a huge, Neptunesque trident trophy.

14

Louison Bobet dies
(13 March 1983)

In 1953 Louison Bobet was riding his sixth Tour. His record so far had been a little inconsistent. He'd finished fourth in 1948 and secured a podium place and the mountains classification in 1950, but he'd also abandoned twice and only managed twentieth in 1951.

A marvellous climber and great against the clock, Bobet would be the first rider to record three Tour wins in a row (1953–55). The early to mid-1950s were his greatest years, adding to those three Tours, wins in Milan–Sanremo, the Tour of Lombardy and Paris–Roubaix. In 1955 he took a Tour of Flanders win that Pierre Chany described as being such a surprise that spectators dropped their cartons of chips in shock.

He also claimed a world championship win in 1954, having to chase back after a wheel change on the penultimate lap to prevail by 22 seconds, ahead of the likes of Coppi, Gaul and a youthful Anquetil. It was the first time in 18 years that a Frenchman had become world champion. '*Maman, je suis champion du Monde!*' he exclaimed afterwards. It needed no translation.

The following year Bobet wore the rainbow jersey as he sought his third Tour title in a row. At the start of stage 11, over the infernal Mont Ventoux and into Avignon, he was over 11 minutes down on the race leader, team-mate Antonin Rolland. With intense Provençal heat scorching the peloton, Bobet attacked. He caught and passed earlier escapees Ferdi Kübler and Raphaël Geminiani and retained his lead all the way to Avignon. Unlikely though it seemed at the time, that stage win over the Ventoux was to be Bobet's last Tour stage victory.

Bobet rode his last Tour in 1959. The Alps finally got the better of him and he climbed off his bike at the summit of the Col d'Iseran. He died in 1983 aged 58.

15

First Paris–Nice gets underway
(14 March 1933)

It was a 4 a.m. start for the riders of the first Paris–Nice. After assembling at the Café Rozes on the Place d'Italie for the roll-out, by 5 a.m. they were racing towards Dijon, over 190-miles (300km) away.

The race was the idea of Albert Lejeune. Lejeune owned two papers: *Le Petit Journal* and *Le Petit Niçoise*, the former based in Paris, the latter in Nice. Lejeune wanted to link the two papers in some way and a bike race between the cities seemed to be just the ticket.

Originally dubbed *Le Six Jours de la Route* – the six days of the road – the idea was to build on both the success of winter six-day racing and the huge popularity of the Tour. Heavily promoted by the two newspapers, the inaugural race was won by Alfons Scheppers.

Today known as the *Course au Soleil* (Race to the Sun), Paris–Nice is one of the most prestigious week-long stage races. Many of cycling's greats have claimed the *course*, among them Louison Bobet, Jacques Anquetil, Eddy Merckx and Miguel Indurain.

Sean Kelly holds the record for most wins. The Irishman first rode Paris–Nice in 1977 as a *domestique* on the Flandria team riding for Freddy Maertens. Maertens dominated the race, claiming five stages and taking the overall win whilst Kelly spent his week riding in the wind. He finished fortieth, over half an hour down.

Kelly won his first Paris–Nice in 1982. It was the start of a remarkable run that saw him win every edition until 1988, collecting 13 stages along the way. Kelly had been so dominant that in 1988, on his way to his final win, he was handed the leader's jersey after the stage to Mont Faron, only for the organisers to later realise that Sean Yates was the true leader of the race. Force of habit you could say. Kelly grabbed the lead for real the following day.

16

Wim van Est is born
(25 March 1923)

Dutchman Wim van Est enjoyed a 16-year professional career during which he won the Tour of Flanders, took three Bordeaux–Paris titles and claimed two Dutch national championships. But van Est is best remembered for an incident on the Col d'Aubisque during the 1951 Tour.

It was the Dutchman's first Tour. On stage 12 he was part of a 10-man breakaway which gained over 18 minutes on the chasing pack. Van Est won the small bunch sprint into Dax to claim the first of his Tour stage wins. He also took over the race lead, becoming the first Dutchman to slip the golden fleece over his head. A stage win and the yellow jersey in his first Tour, all was going well.

The next day took the Tour's peloton into the Pyrenees and over the Aubisque. Van Est was not a good climber but the power of the yellow jersey saw him crest the Aubisque in touching distance of the stage leaders. The descent of the eastern side of the Aubisque is narrow and technical. Van Est didn't handle it well. After a few near misses he hit a low wall and was catapulted from his bike and into a ravine 230-ft (70m) below. Incredibly, he survived. There was just one problem. How to get him out?

A safety rope was fashioned from spare tubulars which rescuers used to lower themselves down to van Est and help him to safety. He abandoned there and then. A team-mate told him afterwards that lying in the ravine in his yellow jersey he looked like buttercup. The incident inspired one of the Netherlands' most famous advertisements. Pontiac Watches, who supplied the Dutch team, ran an ad in the press featuring van Est sitting on a mountainside wearing cycling gear and a pained expression. The slogan ran: 'Seventy metres I fell. My heart stood still. But my Pontiac never stopped! Indeed, a Pontiac can take a beating.'

17

Van Steenbergen wins Flanders
(2 April 1944)

In April 1944 Rik Van Steenbergen was 19 years old. Born in Arendonk, Belgium, he had turned professional just the year before and promptly won Belgium's national championship. Now he was riding his first Tour of Flanders. No one expected much from Van Steenbergen. This was a race for the experienced riders in the peloton. Among the favourites was Alberic 'Briek' Schotte.

Journalist Albert Bakert called Schotte the last of the Flandriens. He rode his first Tour of Flanders in 1940, the youngest rider in the peloton. He came third. He started the race every year of his 20-season career, winning twice and finishing on the podium a further five times. He later estimated punctures and mechanicals cost him up to four more wins. When he rode the race for the last time in 1959 he was the oldest rider on the start line. Schotte and Flanders: from 1940 to 1959; from youngest to oldest.

But 1944 was to be Van Steenbergen's year. Belying his youth, approaching the finish of the 140-mile (225km) race in Ghent, Van Steenbergen was still at the front of the race with eight others, including Schotte. On the approach to the Kuipke velodrome Georges Claes collided with Frans Sterckx. Both fell heavily. Others were forced out wide in order to avoid the chaos. While Sterckx quickly remounted and rejoined the leaders, the crash ended Claes's chances and he trailed in over one minute down. It was Van Steenbergen who had the freshest legs in the sprint and he who claimed the win by one length over Schotte. He became the youngest winner of the race, a record he still holds. Van Steenbergen would add another Flanders title in 1946. He also claimed Paris–Roubaix in 1948 and 1952 and Milan–Sanremo in 1954 and three world championships. (See p51 for more on his 1952 Roubaix win.)

18

71 start, four finish Milan–Sanremo
(3 April 1910)

Heavy rain and biting wind greeted the 71 starters in Milan for the fourth edition of Milan–Sanremo. Worse was forecast. A snowstorm was predicted to hit the Turchino Pass, the race's highest point. Riders wondered if the race might be postponed, or rerouted, but this was 1910 and race organisers liked their cyclists to suffer.

Sure enough, as the race approached the Turchino the rain turned to snow. Riders were forced to dismount. Soon more than 8 inches (20cm)

of the white stuff lay at the roadside. Frozen to the bone, battered by the wind, caked in mud and drenched to the skin, riders abandoned in droves.

Among the starters was Eugène Christophe. Christophe was made of stern stuff and he wasn't about to abandon. Blighted by stomach cramps and numbed and exhausted after the Turchino, he badly needed shelter. Christophe was helped to an inn by a passer-by, where he was given blankets, rum and dry clothes. Once he had dried off, and deaf to the protests of the innkeeper, Christophe went back into the storm. He caught those who had passed him and rode into Sanremo alone to 'enthusiastic applause'. He had been on the road for nearly twelve and a half hours.

Just seven riders finished from the field that started. Three were later disqualified, leaving just four classified finishers. Christophe took a famous win – and spent the next month in hospital recovering.

19

Grégory Baugé wins seventh world title
(7 April 2012)

One of the greatest track sprinters in French cycling history, Grégory Baugé claimed his seventh world title in 2012 when he won the sprint at the world championships held in Melbourne.

Already the possessor of six rainbow jerseys, having won the team sprint world championships four times (2006–9) and the individual match sprint twice (2009 and 2010), Baugé entered the 2012 worlds on the back of a 12 month retrospective ban for missing competition doping tests. The ban was dated from December 2010, meaning Baugé's 2011 results were wiped out, including what had been a third individual sprint world title.

That 2011 title went to Britain's Jason Kenny who had finished to second to Baugé. It was the start of a fascinating 18-month-long duel between the two. At the 2012 worlds Baugé prevailed, dominating Kenny who, having lost the opening race of the three-race final, was forced to go for broke right from the start of the second race. While Kenny actually crossed the line first, he was judged to have hindered Baugé's final sprint: the French star was given the win and his seventh world title.

Four months on and the tables were turned. At the Olympic Games in London in 2012, it was Kenny's turn to stand on the top step, having overpowered the Frenchman in front of a raucous home crowd. In 2015, however, Baugé added world titles eight and nine in Paris.

20

Hinault wins Paris–Roubaix
(12 April 1981)

'*Paris–Roubaix, c'est une connerie*' (Paris–Roubaix is bullshit). That was Bernard Hinault's famous declaration after the 1981 edition of the race. A surprising statement, perhaps, given that he had just won it.

Seven months earlier Hinault had ended France's 18-year wait for a world champion on a course regarded as one of the hardest ever compiled for a world championships road race – a circuit in the French Alps that finished in Sallanches and included 20 ascents of the short but sharp Côte de Domancy. Hinault prevailed on a day of leaden skies and drenching rain to the delight of his nation. Only 15 riders finished, such was the brutality of the racing.

So Hinault had the rainbow jersey on his back at the start of the 1981 edition of the Hell of the North. It wasn't the first time he'd raced on the cobblestones to Roubaix: he'd finished thirteenth in 1978, eleventh in 1979 and fourth in 1980. It had been a long 25 years since Louison Bobet had won Roubaix, the last Frenchman to have done so.

Hinault had prepared well and carried good form into the race, having won the Amstel Gold 10 days earlier. But it's hard to prepare for everything Paris–Roubaix throws at you: Hinault fell seven times during the race, including once when a dog ran out in front of him. At one point he was forced to shoulder his bike and run through a field to prevent getting snarled up in a post-crash delay.

Despite all his crashes and diversions, Hinault entered the Roubaix velodrome at the front of the race with five others, including former winners Roger De Vlaeminck, Francesco Moser and Marc Demeyer. It was the man in the rainbow jersey who prevailed, winning the sprint and ending France's wait for another Roubaix champion.

21

Fiftieth edition of Paris–Roubaix
(13 April 1952)

Perhaps one of the greatest contests Paris–Roubaix has ever seen came as the race celebrated its fiftieth edition in 1952. It featured two very different champions: the graceful Fausto Coppi, more at home in the Grand Tours and the Italian classics (although he had won the race two years previously), and Rik Van Steenbergen, by contrast better suited to the classics of northern Europe, having already claimed the Tour of Flanders twice and the 1948 edition of Roubaix.

With just over 30-miles (50km) to go Coppi was at the head of the race with four others, including Jacques Dupont and Ferdy Kübler. Van Steenbergen trailed far behind. Then the Belgian, who had started the previous weekend's Tour of Flanders as one of the favourites only to abandon, launched a furious pursuit. For his part, Coppi just drove harder, shelling the remnants of the break off his wheel until he was alone.

But Van Steenbergen, showing immense strength of both limb and will, bridged the gap to the Italian. There was now less than 12-miles (20km) to go. Coppi had to get rid of Van Steenbergen before they reached the velodrome. He knew a sprint would be a formality for the Belgian.

Time and time again Coppi attacked but somehow Van Steenbergen clung on. Coppi threw everything he had at the Belgian but it wasn't enough. Attack after attack was repelled by the steely Belgian. Finally they entered the velodrome together where, as Coppi knew he surely would, Van Steenbergen won the sprint. Afterwards the Belgian, clearly in some distress, with dead eyes peering out from a dirt-encrusted face, admitted that just one more burst from Coppi would have ended his race.

22

Fischer wins first Hell of the North
(19 April 1896)

It is dubbed *l'Enfer du Nord*. The Hell of the North. So named because the menacing stretches of cobblestoned roads known as *pavé* that punctuate the second half of the race cross the scene of some of the bloodiest battles fought during First World War, Paris–Roubaix is the biggest one-day classic on the racing calendar today.

The first edition was held in 1896 when textile merchants Théodore Vienne and Maurice Perez, keen to capitalise on the burgeoning popularity of cycle racing, hit upon the idea of a race from Paris to the velodrome they had built in Roubaix. Having convinced the management team behind the sports paper *Paris-Vélo* to back the project, the race was on.

Initially billed as a warm-up for the Bordeaux–Paris classic, the race was won by Germany's Josef Fischer who claimed the 1000 francs on offer for first place. Fischer had joined Arthur Linton at the head of the race after he'd completed a furious pursuit of the Welshman having been four minutes behind at Beauvais. Linton was then brought down by a runaway dog at Amiens, leaving the way clear for Fischer. The German won by 25 minutes, ahead of Denmark's Charles Meyer. Maurice Garin, the future Tour de France winner was third just two minutes back. Linton was fourth. No-one else finished within an hour of Fischer.

Also known as the Queen of the Classics, or *La Pascale* (the Easter race), after Fischer's win Paris–Roubaix grew into the most prestigious of all of cycling's one-day races. Having had to wait until the thirteenth edition for its first win (Cyrille Van Hauwaert in 1908), Belgium currently holds the record for most wins, having claimed 55 of the 114 editions contested at the time of writing.

23

Hippolyte Aucouturier dies
(22 April 1944)

With a handlebar moustache and often wearing a thickly striped jersey and flat cap, the splendidly named Hippolyte Aucouturier was a racing cyclist in the early to mid-1900s who bore more than a passing resemblance to the archetypal circus strongman.

Nicknamed *le Terrible* by Henri Desgrange, Aucouturier was a long-distance specialist and one of favourites for the first Tour de France in 1903. He abandoned the first stage but in those days riders were allowed to continue to go for stage wins (although they were no longer eligible for the overall win). Aucouturier stayed and picked up two stages. He was among the riders disqualified from the 1904 race (see 2 December), and finally recorded a spot on the Tour's podium in 1905, when he finished second and claimed three more stage wins. It was to be his best performance at the world's biggest race.

Away from the Tour, Aucouturier won Paris–Roubaix twice in a row (1903 and 1904) as well as claiming two wins at Bordeaux–Paris, at the time a more prestigious race than Roubaix. His first win in the 357-mile (575km) marathon came in 1903, one month after his first Roubaix triumph. Aucouturier employed some 35 pacers to guide him to Paris. He was engaged in a fierce battle with Louis Trousselier at the head of the race but finally pulled away after multiple attempts to lose his rival in the closing kilometres. 'Finally, on a hill, I redoubled my efforts and, not without difficulty, left my tenacious opponent,' he recalled later. Aucouturier won by seven minutes and set a new record for the race. 'It is immensely satisfying,' he said.

24

The Florist wins Paris–Roubaix
(23 April 1905)

Louis Trousselier, dubbed the Florist because of his family's flower business, enjoyed the best year of his career in 1905 when he won both Paris–Roubaix and the Tour de France, the first time a rider had won both races in the same year. If that doesn't sound particularly remarkable given that the Tour was only in its third year at the time, it takes on new meaning when you consider that only three riders have achieved the same feat since: Octave Lapize (1910), Eddy Merckx (1970) and Bernard Hinault (1981).

Trousselier's win at Roubaix came ahead of René Pottier and Henri Cornet. Cornet had attacked early on and at one point had gained four minutes. But it was Trousselier who would prove to be the strongest. He finally took a grip on the race and led into Arras, going on to win by seven minutes.

Three months later he took to the start line of the Tour. He won the first stage into Nancy taking the race lead. He then lost it for a day to Pottier before winning the third stage and reclaiming the overall lead. Now there was no stopping him. An army conscript, he should have been starting his military service, instead he was dominating the world's biggest bike race. He took complete control and, with a new points system having been introduced to calculate the General Classification instead of elapsed time, by the time the race hit Bordeaux on stage seven, Trou-trou's lead was such that he only had to finish to win. 'I'm not sorry it's over,' he said in Paris. 'At least I can sleep until noon.'

The Florist would go on to win another seven stages at the Tour and add Bordeaux–Paris to his *palmarès* in 1908. The onset of war in 1914 brought an end to Trousselier's professional cycling career. He died in 1939.

25

The birth of Vélocio
(29 April 1853)

Paul de Vivie was a silk-factory owner who in the 1880s became obsessed with the bicycle. Born in Pernes-les-Fontaines, so smitten was he that he sold up, moved his family to St-Etienne, opened a small bike shop importing cycles from Britain and started a magazine called *Le Cycliste* celebrating all things cycling. The magazine, most of which he wrote himself, signing off as Vélocio, encouraged people to get out on a bike and grew increasingly influential. He is known as the father of cyclo-tourism but it is his work developing multiple gears in the early 1900s that is his lasting legacy, paving the way to the modern *derailleur*.

Amazing as it may seem today when new technology is embraced, the cycling world was stubbornly resistant to de Vivie's thinking. Henri Desgrange labelled it as something artificial, saying it was 'better to triumph by the strength of your muscles' and deriding it as being something for grandparents.

Through his magazine de Vivie published lots of advice for the cyclo-tourist, including his seven golden rules of cycling;

1. Keep your rests short and infrequent to maintain your rhythm.
2. Eat before you are hungry and drink before you are thirsty.
3. Never ride to the point of exhaustion where you can't eat or sleep.
4. Cover up before you are cold, peel off before you are hot.
5. Don't drink alcohol, smoke, or eat meat on tour.
6. Never force the pace, especially during the first hours.
7. Never ride just for the sake of riding.

De Vivie died in 1930 when he was hit by a tram in St-Etienne while pushing his bike.

26

Poulidor starts Vuelta for the first time
(30 April 1864)

Best known for his rivalry with Jacques Anquetil at the start of his career, and then for standing on the podium of the Tour eight times but never winning it – a feat for which he became known as 'the eternal second' – Raymond Poulidor won his only Grand Tour in 1964 when he claimed the Vuelta a España.

His nickname was more than a little harsh. Poulidor was a classy rider whose career just happened to fall in a period ruled first by Anquetil and then by Eddy Merckx, two of the greatest riders of all time.

His rivalry with Anquetil engaged France. At the 1964 Tour de France the pair battled not just for the yellow jersey but for honour. Things came to a head on the Puy de Dôme when for more than 1.8-miles (3km) they rode alongside one another, neither ceding to the other. Chased by press and cameramen on motorcycles, at one point they came together: eyes fixed in downward stares, shoulders and elbows clashed, bikes wavered. The cameras whirred into action. The resulting photograph has become one of the race's most iconic images. Poulidor cut Anquetil's lead from 56 seconds to just 14 that day but it wasn't enough and Anquetil again prevailed in Paris.

Two months before that famous stage, Poulidor had been in Spain. That 1964 edition took in 1,777 miles (2,860km) across 17 stages (two were split). Eighty riders started, with 49 making it to the finish in Madrid. At the top of the classification sat Poulidor. His final margin was just 33 seconds over Luis Otaño. Poulidor would go on to win Paris–Nice and the Critérium du Dauphiné before retiring from racing at the end of the 1977 season.

27

Henri Pélissier, convict of the road, is shot dead
(1 May 1935)

Henri Pélissier was one of France's first great riders but his life both on and off the bike was mired in controversy. In an 18-year career punctuated by war, Pélissier, who was advanced in his training methods, concentrating on speed, diet and equipment rather than just pure endurance, won 10 stages of the Tour de France as well as the overall title in 1923.

He was a prickly character who repeatedly took issue with what he saw as petty officialdom. In 1924, along with his brother Francis and a team-mate, he abandoned the Tour during its third stage after being quizzed by officials over how many jerseys he had started the race with – the rules being that you had to finish with exactly the same equipment and clothing that you had started with.

The abandoning of Pélissier was big news. The riders showed journalist Albert Londres the contents of their bags: 'That, that is cocaine for our eyes and chloroform for our gums…' Henri told Londres. 'We run on dynamite,' said Francis. The article itself was dynamite. Splashed on the front page of the next day's *Le Petit Parisien*, it became one of the most explosive pieces of cycling journalism of the age. The article was later dubbed *les forçats de la route* – 'the convicts of the road'.

Less than 11 years later, the 'convict' was shot dead. Pélissier's wife had committed suicide in 1933 and by 1935 he was in a relationship with Camille Tharault. During a violent row with Tharault and her sister, Pélissier pulled a knife and cut Tharault's face. Tharault told the subsequent investigation that she feared for her life when she grabbed the gun and shot her lover dead.

'The tragic end of a champion,' ran the headline in *Le Petit Journal*.

28

The narrowest ever Grand Tour win is recorded
(6 May 1984)

When Frenchman Eric Caritoux stood on the top step of the final podium at the 1984 Vuelta it was with the narrowest margin of victory recorded in Grand Tour history.

Prior to Caritoux's six-second win, over Alberto Fernández Blanco of Spain, the record had been shared by Fiorenzo Magni and José-Manuel Fuente who had both recorded 11-second victories in the 1948 Giro and 1974 Vuelta respectively. The narrowest win at the Tour at that point was Jan Janssen's 38-second win in 1968, later usurped by Greg LeMond when he famously beat Laurent Fignon by eight seconds in 1989, overhauling the Frenchman during the final day's time trial on the Champs-Elysées.

It was by far the biggest win of Caritoux's career, although he did later claim back-to-back national championships (1988 and 1989). Caritoux took over the race lead on the stage to the Lagos de Covadonga and managed to hold it until Madrid despite Fernández Blanco coming back at him over the course of the final time trials.

Ultimately, Fernández Blanco ran out of road. Nicknamed the Biscuit (he lived in a town famous for its biscuits), the year before he had finished third in the Giro. He also had a top-10 finish at the Tour behind him. Aged 30 it seemed he was now a genuine Grand Tour contender. Sadly his life was cut short just seven months after this narrow defeat when he and his wife were killed in a car accident.

He is remembered by the race he so nearly won, with a prize awarded to the first over the highest point of any Vuelta, named in his honour.

29

Beryl Burton is born
(12 May 1937)

It is September 1967. Beryl Burton has just won the world championship road race for the second time by riding away from the field 22-miles (35km) from the finish to beat Russia's Lubov Zadoroznaya by 1 minute, 47 seconds. She has returned from that race in the Netherlands to barely a flicker of the coverage that such an achievement would receive today. Now she is back in her home county of Yorkshire and at the start line of the Otley CC's 12-hour time trial.

Burton sets off two minutes after Mike McNamara, the last competitor in the men's event. Despite preparing well she doesn't feel her best and over the next 12 hours will suffer mechanical problems and stomach pains. Later she will say that when she started she had doubts as to whether she could finish.

But Burton would do more than finish. After steadily gaining on McNamara throughout her ride she finally passes him. As she does so,

Burton reaches into her pocket, pulls out a stick of liquorice and offers it to McNamara. His reported response? 'Ta, love.'

McNamara set the record for the best performance by a man in a 12-hour time trial that day: 276.52 miles (445.02km). Burton beat it. She covered 277.25 miles (446.19km) before climbing off her bike at the foot of a hill with nearly a minute of her 12 hours still to go. It was the only time the women's record had outstripped the men's.

But, then, Burton was special. Born in Leeds, she went on to dominate the domestic racing scene for over a quarter of a century. Her achievements over the course of her 30-year career are staggering: seven world titles (two on the road, five on the track), 70 national time-trial championships (distances ranging from 10 to 100 miles/16-160km), 13 pursuit and 12 road race national titles and every national time-trial record from 10 miles to 12 hours. For 25 years in a row she won the Best British All-Rounder title, awarded to the nation's most complete time-trial rider.

Even more remarkable is the fact that all the above was accomplished as an amateur, with Burton combining her cycling with her work on a rhubarb farm. She was made an MBE in 1964 and an OBE in 1968.

Beryl Burton died of heart failure in 1996 at the age of 58 while out riding her beloved bicycle.

30

The first Giro d'Italia starts
(13 May 1909)

Buoyed by the success of one-day races Milan–Sanremo and the Tour of Lombardy, and fearful of rival publication *Corriere della Sera*'s own plans to launch a national tour, in August 1908 *La Gazzetta dello Sport* hastily, but boldly, announced a new bicycle race. There, on its front page, were the details of the new Giro d'Italia. It would take place the following spring. It would take in 1,860-miles (3,000km). It would offer 25,000 lire in prize money. It would, in short, be 'one of the biggest, most ambitious races in international cycling'.

Initially sponsorship was hard to come by and at one point the race was postponed but eventually funds began to trickle in and on the morning of 13 May 1909, 127 riders set off from the Via Monza in Milan for an eight-stage race. The race attracted many of the top riders of the age. Among the Italians riding were Giovanni Gerbi, the first winner of the Tour of Lombardy, and Luigi Ganna, the winner of Milan–Sanremo just one month earlier. And it would be Ganna who prevailed.

A bricklayer who honed his cycling legs riding 62 miles (100km) a day to and from work, Luigi Ganna turned to professional cycling after an impressive third place behind Gerbi in the first Tour of Lombardy convinced him, and his family, that he could earn far more money by riding a bike for a living than he could by building houses.

That third place helped earn him a contract with the Bianchi for the 1906 season. A strong, powerful rider, good in bad weather, they called Ganna the King of Mud. He retired in 1915, entering the world of bike manufacture. His company went on to sponsor a professional team for more than 20 years. In 1951 Ganna claimed the Giro title again when Fiorenzo Magni won the second of his three Giri titles whilst riding for his team.

31

Willie Hume wins in Belfast and changes cycle racing
(18 May 1889)

In 1889 the penny-farthing was still the steed of choice for those wanting to win bicycle races. It was considered to be much quicker than the then new 'safety bicycle', the fundamentals of which went on to give us the bike as we know it today.

Willie Hume was a cyclist in Belfast. He wasn't the best in the city but he had something that others didn't – a bit of vision. A few years earlier John Boyd Dunlop had invented the pneumatic tyre. At the time, racers used solid tyres and weren't convinced by the new development. Dunlop's invention had been laughed at and dubbed sausage tyres.

That all changed on 18 May 1889. Hume, the captain of the Belfast Cruisers' Cycling Club, preferred to ride a safety bicycle, having suffered a bad fall from a penny-farthing. He fitted Dunlop's pneumatic tyres to his safety bicycle and entered four races at the North of Ireland Cricket Club in Belfast. He won all four. Then he went to England and won there.

All of a sudden people understood that inflatable tyres were not to be sneered at and that they not only made riding safer, easier and more comfortable, but made you faster as well. The following year Dunlop set up commercial production and soon the pneumatic tyre was the tyre of choice for racers everywhere.

32

Last Peace Race finishes
(20 May 2006)

When Italian rider Giampaolo Cheula stood on the top step of the podium at the end of the 2006 edition of the Peace Race in Hanover, Germany, he stood as the final winner of what had arguably been the most important of all bike races.

As the Iron Curtain was drawn across Europe after the Second World War, its impenetrable weight dividing east from west for decades to come, Poland, Czechoslovakia and Germany turned to a humble bike race in an attempt to build unity and identity.

The first race was in 1948, a five-stage affair from Warsaw to Prague. With no professional sport in the Eastern Bloc, the race was for amateurs only; however, with peace and solidarity central to its ideology it was open to all nationalities, regardless of political persuasion. That spirit of openness was severely tested in 1950, the year it took the name of the Peace Race for the first time and adopted the dove as its symbol, but when the German Democratic Republic (GDR) asked to send a team it wasn't well received. The scars of war were still raw; Germany was the pariah of Europe.

The GDR's inclusion was a small but important step in the process of reconciliation. Heralded as the Tour de France of the East, over its 58-year history the race brought millions out on to the streets, as they cheered on their sporting heroes.

With the fall of the Iron Curtain, the race turned professional in the 1990s and by the time of its last edition was part of the UCI calendar. Steffen Wesemann of Switzerland holds the record for most wins with five victories but the race's most noteworthy winner is Täve Schur, who recorded the GDR's first win in the race in 1955 and was the first to record a second victory (in 1959).

33

Mark Cavendish is born
(21 May 1985)

Nicknamed the Manx Missile for his furious turn of speed as the finish line approaches, Isle of Man-born Mark Cavendish is the most successful sprinter in Tour history. With 30 stage wins to his name at the time of writing, he is second on the all-time stage wins list, behind only five-time race winner Eddy Merckx.

Cavendish is also the only rider in history to have won the Tour's final stage on the Champs-Elysées four times. His victory in 2012 took Cavendish into the record books for two reasons: he became the first rider to have won the stage four times in succession and, as world champion, it was the first time that the rainbow jersey had won the stage.

If the sight of his team-mate Bradley Wiggins, resplendent in yellow, leading out Cavendish in the rainbow jersey, to win on the Champs Elysées, really rammed home the message that British cycling had arrived, Cavendish's most astonishing victory in Paris perhaps came in 2010. Then, with the side-view camera showing Thor Hushovd and Alessandro Petacchi sprinting to the line, Cavendish, who was out of shot, emerged behind them and showed a startling turn of speed. Suddenly it looked like Hushovd and Petacchi, two of the fastest men in the world, were mere tourists. Cavendish simply blasted past them as if he was a rocket launched into space. Untouchable.

Away from the Tour, Cavendish has won 18 stages across the Giro and Vuelta and taken the points jersey at both. In 2009 he won his only Monument to date, Milan–Sanremo. Two years later he took the world championships. Cavendish's rainbow jersey-winning ride saw him at the peak of his power and was the culmination of a long-term plan devised by British Cycling (the national body for cycling in Great Britain) to deliver a British winner at the worlds.

34

Brits conquer the first Bordeaux–Paris
(23 May 1891)

If a 355-mile (572km), one-day race seems crazy in the modern age, just imagine what it must have been like back in the 1890s on single-geared machines that weighed about the same as a small house. That's what faced the 28 riders who set out from the Place du Pont in Bordeaux at five o'clock on the morning of 23 May 1891. Organised by *Le Véloce-sport*, a Bordeaux-based cycling periodical, the new Bordeaux–Paris race was designed to test the staying powers of that age's greatest riders. Long-distance racing on the relatively new invention of the bicycle was *en vogue*. This race was designed to push the limits of what was possible.

It was won in 26 hours, 35 minutes by George Pilkington Mills. A 24-year-old from London, Mills was a long-distance specialist who gathered an armful of records that seem quite incredible even today, but considering the bicycles he was riding and the road conditions he faced, they seem almost impossible – Land's End to John O'Groats in three days and 16 hours? In 1893? On a tricycle? It seems barely plausible.

British riders dominated that first Bordeaux–Paris, claiming the top four places. Mills made his move at Angoulême. Instead of stopping for food like the others he dunked his head in a bucket of water and carried on. There were still over 250-miles (400km) to go but Mills would eventually cross the finish line at the Boulevard de la Porte-Maillot, Paris 26 hours, 35 minutes after he left Bordeaux. Fellow Brit, Monty Holbein finished an hour and a quarter later.

Mills's performance was hailed by the organisers as one of the most extraordinary performances ever achieved.

35

Jacques Anquetil takes a unique double
(30 May 1965)

In 1965 Jacques Anquetil's *directeur sportif*, Raphaël Geminiani, set his star rider a seemingly impossible challenge: to win the stage-race Critérium du Dauphiné and then hotfoot it across southern France to take on the Bordeaux–Paris long-distance classic, which started just seven hours later. 'A feat that only you are able to achieve,' Geminiani told Anquetil. At first Anquetil thought the idea insane. If nothing else, just getting to Bordeaux in time for the start was going to be a major logistical challenge. Nevertheless, Geminiani finally convinced his charge, telling him it would capture the imagination of the public. The challenge was on.

At the Dauphiné he was up against his biggest rival, Raymond Poulidor. Anquetil won three of the 10 stages, took the race lead on stage three and held it until the finish in Avignon. Phase one was in the bag. At midnight Anquetil was on the start line of the 346-miles (557km) long Bordeaux–Paris. He had barely slept and yet he was about to take on one of the toughest one-day races in cycling. Early on, Anquetil was suffering. It was cold and there was a strong headwind. Dawn was still to break. He'd had enough and wanted to quit. It was only the words of Geminiani that kept him going. François Mahé rode into a lead of six minutes, as riders began attacking Anquetil constantly, but he bided his time. Then, when his team-mate Jean Stablinski started a pursuit of Mahé, Anquetil latched on.

After a furious chase Stablinski and Anquetil passed Mahé. Joined by Britain's Tom Simpson, the three rode towards Paris until Anquetil dropped them around 12-miles (20km) from the finish, riding into the Parc des Princes alone. Twenty thousand people greeted him, chanting his name for minutes after he crossed the finish line. 'This may be my best win,' said the five-time Tour champion.

36

Gino Bartali awarded Medaglia d'Oro al Merito Civile

(31 May 2005)

Italian Gino Bartali enjoyed a hugely successful 20-year career. Deeply religious, Bartali had his first yellow jersey blessed by a priest and used to go to Mass during races, earning him the nickname Gino the Pious.

Born in Tuscany in 1914, Bartali worked as a bike mechanic before he turned professional in 1935. Immediately he started winning, claiming the national championship road race and later the Giro and the Tour. But his life's greatest work came during the Second World War. Still training, despite races being cancelled, Bartali was often stopped and searched by members of the Fascist Party while he was out covering kilometre after kilometre on his bike. A beloved sporting hero, he was able to ask them to leave his bicycle untouched as it was exactly set to his measurements. This proved crucial as hidden in the bike's frame and under its saddle were counterfeit papers that Bartali was smuggling to help the Jews of Italy escape persecution.

His actions went beyond the vital courier work – he sheltered one Jewish family in his cellar for nearly a year. In all it is estimated that Bartali helped save 800 Jews.

The full extent of his actions only came to light after his death.

In May 2005 Bartali was awarded Italy's Medaglia d'Oro al Merito Civile for his 'wonderful example of great spirit of sacrifice and human solidarity'. In 2013 the state of Israel awarded him the honour of Righteous Among The Nations – given to those who risked their own lives to save the lives of Jews. For his part Bartali never spoke of his actions nor courted recognition for them, saying only: 'Some medals are pinned to your soul, not to your jacket.'

37

The first Cima Coppi
(4 June 1965)

Mountains have long played an integral part in Italy's national tour. In 1933 the organisers introduced a prize for the best climber, and in 1965 they decided to introduce a prize in honour of Italy's greatest ever cyclist. The Cima Coppi was to be awarded to the first rider over the highest point of the race. In 1965 that meant the Stelvio.

This was the mountain upon which Coppi had forged his fifth Giro win 12 years earlier. Then he had entered the Giro with high

expectations of adding the 1953 race to the four titles he already had in the bag. But it hadn't gone to plan. Hugo Koblet took the race lead on stage eight and kept it until the final week. With two stages left Coppi was two minutes down. With the race seemingly over he congratulated the Swiss and talked only of aiming for the next stage win. That next stage was over the Stelvio. Coppi's lover was coming to watch and he wanted to impress. He attacked on the climb and left an unsuspecting Koblet for dead. Coppi had stolen the pink jersey with one stage to go.

The Stelvio is a monstrous climb: it reaches up to 9,049 feet (2,758m), and has a maximum gradient of 14 per cent with an average of 7 per cent. And it is long: 14 miles (22km) from Bormio, 15 miles (24km) from Ponte di Stelvio.

In 1965 stage 20 finished at the top of the brutish climb. It had snowed heavily blocking the road and forcing the riders to dismount. Graziano Battistini won, becoming the Giro's first Cima Coppi. Ironically he did it on foot.

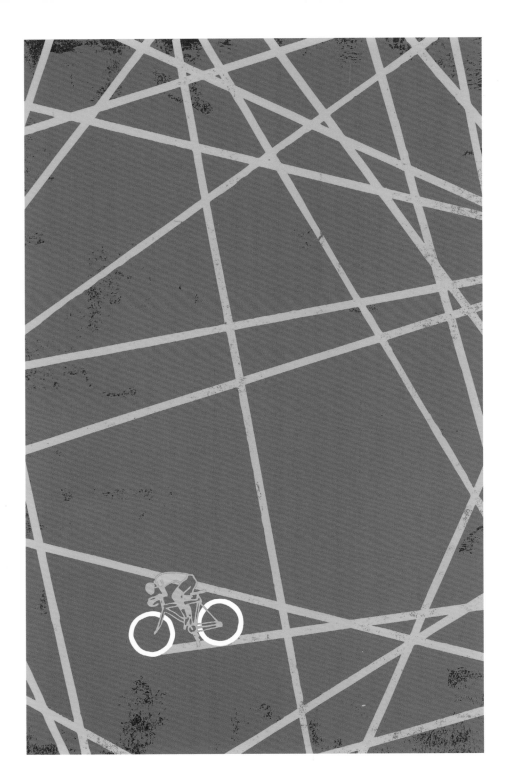

38

Gianni Bugno wins the Giro
(6 June 1990)

Only four riders have held the race lead in the Giro d'Italia from the first stage to the last: Costante Girardengo (1919), Alfredo Binda (1925), Eddy Merckx (1973) and, in 1990, Gianni Bugno.

Bugno was a versatile rider, a rare cyclist who could win classics, world championships and Grand Tours. The best years of his career were from 1990 to 1992, when he won Milan–Sanremo, the Clásica de San Sebastián and back-to-back road races at the world championships in 1991 and 1992, beating the Netherlands' Stephen Rooks and France's Lauren Jalabert respectively.

Bugno's most dominant performance, however, came in the 1990 Giro. He took the first pink jersey of the race, a 8-mile (13km) time trial in Bari, finishing three seconds ahead of time trial specialist Thierry Marie. He came within one second of losing it the next day but managed to cross the line in the nick of time to stop Marie stealing the jersey from him. Over the next week he steadily increased his margin without really disappearing out of sight.

That is until stage 10. A dominant performance in the 42-mile (68km) time trial secured him a lead of over four minutes. After winning his second time trial on the penultimate stage, Bugno's winning margin grew to over six minutes, beating Charly Mottet into second place.

Bugno's win meant he joined three legends of the sport in leading the Giro from start to finish, the first to have done so since Merckx some 17 years earlier. No-one has repeated it since.

39

LeMond's comeback
(11 June 1989)

In the year LeMond started his first Tour, 1984, he was one of just two Americans on the race (Jonathan Boyer was the other). By 1986 that had grown to 10 and included the 7-Eleven team, the first American team to take to the Tour's start line.

His first Tour ride brought him a podium place – third behind Laurent Fignon and Hinault. A year later he took one step up the podium but remained behind Hinault. Then, in 1986, he finally made the top spot after a legendary battle between LeMond and Hinault, rivals who happened to be on the same team.

On 20 April 1987, LeMond was spending time at a family-owned ranch in the foothills of the Sierra Nevada Mountains in California. He was out hunting when his brother-in-law, Patrick Blades, mistakenly shot him. Trauma specialists said he would be back to normal in a couple of months. In fact it took LeMond a couple of years.

In May 1989 he went to the Giro. During a torrid three weeks he had to use every ounce of strength and determination simply to survive. Then, on the final stage, a 34-mile (54km) time trial, LeMond stunned everyone, coming second and putting over one minute into pink jersey Laurent Fignon. He was back. A month later he entered the final stage of the Tour trailing Fignon by 50 seconds. For the first time in 18 years, the final stage of the 1989 race was a time-trial. Fignon, with his metal-rimmed glasses and ponytail flowing, cut a distinctly old-school figure against LeMond with his Oakleys, custom time-trial helmet and tri-bars.

Fignon, last out, desperately sprinted to the line. The clock ticked on, past the all-important time with Fignon still on the road. It was over. LeMond had beaten Fignon at the very last moment to record the narrowest ever Tour win.

40

The Bernina Strike
(12 June 1954)

The penultimate stage of the 1954 Giro d'Italia was a mountainous affair into St Moritz. The previous year's race had been a classic showdown between Fausto Coppi and Hugo Koblet and the Giro's organisers were hoping for a repeat performance.

Italy was suffering a heatwave and the race was long (2,695 miles/ 4,337km) and hard. The riders argued amongst themselves and with the organisers, Coppi himself was ill and distracted – his life away from the bike and his relationship Giulia Occhini was under intense media and public scrutiny.

On stage six a breakaway formed and won by a huge margin. Koblet's team-mate, Carlo Clerici, took the lead – 35 minutes over Koblet, 45 over Coppi. Koblet announced he would now work for Clerici.

The race became a procession. With no one inclined to take on Clerici, Italy's biggest race turned into nothing short of a farce. Fans and media were incensed and Coppi bore the brunt of their ire. He was shouted at and threatened. Journalists wrote that he had neither the morale nor the condition to compete – although he proved them wrong with a stage win over the Pordoi and Gardena climbs.

The day after that stage win, the disgruntled riders called a strike. The stage over the Bernina Pass and into St Moritz, the one designed to be action-packed and intended to decide the Giro, was instead ridden at the peloton's leisure, much to the disgust of organisers and fans. The go-slow meant that it took the peloton over nine hours to ride the 138-mile (222km) stage. Clerici won the Giro. Coppi lost the love of Italy. And the 1954 Giro became the race of the Bernina Strike.

41

Ottavio Bottecchia fatal training ride 'accident'
(15 June 1927)

Born into a large family in 1894, Italian Ottavio Bottecchia, nicknamed the Butterfly by Henri Desgrange, joined the Automoto team in 1923, after finishing fifth in that year's Giro as an independent rider. Bottecchia was thrown straight into the Tour, riding for Henri Pélissier. He was an instant hit, wearing yellow for six days. Pélissier won the race, Bottecchia came second with his leader tipping him as a rider who would one day win the Tour.

The following year, he won the opening stage, slipping on the first yellow jersey of the year. He didn't remove it until the race returned to Paris, some 15 stages and 3,370 miles (5,425km) later. Bottecchia took four stages in total, including two tough days in the Pyrenees where he soared over the very worst the range could throw at him, *en route* to becoming the first Italian winner of the Tour, with a final margin of over 35 minutes. In 1925 he won the Tour again with a winning margin even more impressive than before – 54 minutes.

But then the tale turns dark. Having abandoned the 1926 race, Bottecchia was determined to return in 1927. On 3 June he went out training early. He would never return home. He was found, hours later, by the roadside, with head injuries and broken bones. A priest was called and he was given the last rites before being taken to hospital where he remained until 15 June, when he died.

Theories abounded as to what had happened. Some pointed to a crash, though his bike bore no evidence of any such incident; others to the farmer who had summoned the priest. Others talked of a Fascist plot to kill the great champion after his failure to fully support their cause. The truth was never uncovered, and the death of Ottavio Bottecchia remains shrouded in mystery to this day.

42

Francesco Moser is born
(19 June 1951)

Only two men have won Paris–Roubaix three years in succession: Octave Lapize (1909, 1910 and 1911) and Italy's Francesco Moser, who started his own run on Roubaix in 1978.

Nicknamed the Sheriff, Moser was wearing the rainbow jersey when he claimed his first Roubaix cobblestone trophy. He entered the Roubaix velodrome alone. He escaped 12-miles (20km) from the finish despite the best efforts of Freddy Maertens and Jan Raas. He has since said that the 1978 season saw him at his best. Moser's solitary entrance would be something he would repeat in 1979 and 1980.

While Roubaix was Moser's favourite hunting ground he took many other important wins over the course of his 15-year career. He won 23 stages at the Giro and claimed the pink jersey in 1984. He also won the Tour of Lombardy, Milan–Sanremo, Tirreno–Adriatico, La Flèche Wallonne and Ghent–Wevelgem. He only rode one Tour, in 1975. He took two stage wins, wore yellow for a week and came seventh in Paris, but never returned.

He retired in 1988 with over 300 victories on road and track to his name but returned to action in 1994, when he was 43 years old, to have another tilt at the hour record. Ten years earlier he had travelled to Mexico City, succesfully bettering the previous mark over four days of riding. His record of 55,939 yards (51,151m) stood for nine years but was beaten in 1993 by the Scotsman Graham Obree. Shortly afterwards, Chris Boardman took the record. So, in January 1994, Moser returned to Mexico, intent on improving Boardman's record. Unfortunately he fell short by 470 yards (430m). Moser's performance was, at least, the best achieved by a veteran.

43

The longest Tour starts
(20 June 1926)

Henri Desgrange famously liked his races long and hard. In 1926 he devised a route that would be the longest in history.

The race started in Evian, the first time it had started outside Paris, and the lakeside town was the flavour of the month: three and a half weeks after it hosted the *grand départ*, the race returned for stage 15's finish and the start of stage 16.

The total race distance was 3,570 miles (5,745km) over 17 stages, making the average stage distance a whopping 210 miles (338km). The longest was 269 miles (433km), from Metz to Dunkirk, won by Gustaaf Van Slembrouck who outsprinted team-mate and compatriot Albert Dejonghe to take the win after over 17 hours in the saddle.

Slembrouck was a Belgian rider who recorded podium finishes at the Tour of Flanders, Paris–Roubaix and Bordeaux–Paris over the course of an eight-year professional career. His four Tour stage wins (he would win another three, two in 1927 and one in 1929) would be the highlight of his career.

The race's first yellow jersey was worn by Jules Buysse, after a 99-mile (160km) solo escape into Mulhouse left him 13 minutes ahead of the rest. Van Slembrouck's win in Dunkirk brought him the race lead which he held until the race hit the Pyrenees. Then, Buysse's brother, Lucien, took over the race, taking yellow and and keeping it until Paris following a tremendous performance in the Pyrenees (see 11 September).

44

Kübler and Koblet go toe-to-toe in the Tour du Suisse
(23 June 1951)

In the 1950s Switzerland had two riders at the top of the sport: Hugo Koblet and Ferdinand Kübler. In 1950 Koblet won the Giro d'Italia, the first Grand Tour win by a Swiss rider, when Fausto Coppi crashed out.

Two months later Kübler, who had finished fourth in Rome, took the yellow jersey at the Tour de France when he rode into Paris and mounted the podium more than nine minutes ahead of Belgium's Constant 'Stan' Ockers. His victory, however, owed more than a little to the events of a nasty crash two weeks earlier on the Col d'Aspin that had led Bartali to demand all Italian riders to abandon the race in protest.

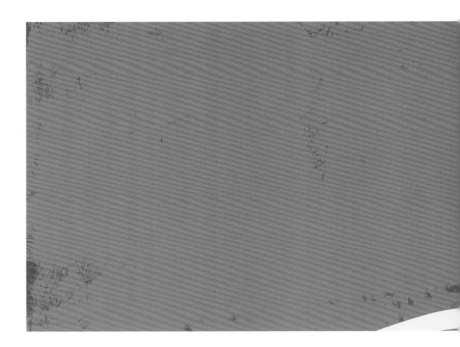

It was at their own Tour du Suisse however, that Kübler and Koblet clashed most often. Kübler, the elder of the two by six years, had won the race in 1942 and 1948. Koblet had taken his first in 1950. Going into the 1951 race the question was whether Koblet could win to match Kübler's haul, or if Kübler would exert himself and take a third win.

Early on, the two traded stage wins but the defining day was the 155-mile (249km) stage into Lugano. Koblet was best placed on GC but Kübler came second in Lugano, more than eight minutes ahead of Koblet who punctures four times, and taking over the race lead.

Koblet tried to strike back on the penultimate stage to Davos, winning by nearly a minute over his great rival, but it wasn't enough. Kübler prevailed and won his third title. Koblet finished second overall, more than four minutes back, those punctures costing him the win.

Koblet, dubbed the pedaller of charm by French singer Jacques Grello, would go on to win the Tour de France six weeks later. He would return to his own national tour and win in 1953 and 1955. He ended his career with three Tour de Suisse wins, the same number as his great rival Kübler.

45

Federico Bahamontes abandons the Tour
(27 June 1960)

Nicknamed the Eagle of Toledo, and already a two-time winner of the Tour's mountains classification, Federico Bahamontes won the yellow jersey in 1959. He was Spain's first Tour champion but his win wasn't universally acclaimed.

He took over the race lead on stage 17, when he joined Charly Gaul in an escape on the 122-mile (197km) stage into Grenoble. Gaul took the stage, Bahamontes took yellow. The French team was in tatters with Jacques Anquetil and Roger Rivière at loggerheads, swearing to ride against each other, and the best placed Frenchman Henry Anglade, the national champion but still a regional rider.

The next day, over the Lauteret, Galibier, Iseren and Petit-St-Bernard climbs, a group went away and built a lead over Bahamontes approaching five minutes. Among those in the group were Anglade, Anquetil and Rivière. That lead meant that Anglade was the leader on the road, the virtual yellow jersey. But Anquetil and Rivière then refused to contribute to the attack and the momentum faltered. Bahamontes came back and limited his losses to Anglade to just 47 seconds. The French had missed their opportunity.

The following year Bahamontes quit the race after just three stages, suffering with a knee injury. Having famously once stopped at the top of climb, grabbing an ice cream while waiting for a change of wheel, it was in the mountains that Bahamontes made his name. He ended his career with six mountain prizes at the Tour, two at the Vuelta and one at the Giro, the first rider to win the classification at all three Grand Tours.

46

The Badger rides the Tour for the first time
(29 June 1978)

By the time of the 1978 Tour, Bernard Hinault was already a force in world cycling. He'd won the Dauphiné, Liège–Bastogne–Liège and, just six weeks earlier, the Vuelta a España. Now it was time to tame the biggest race of them all.

Known as the Badger for his aggressive style, Hinault proudly wore the jersey of the French national champion and was considered one of the favourites. But this was Hinault's first Tour. How would he fare against the world's best? Hinault won stage eight's time trial, riding impressively in the Pyrenees to exit the mountain range second overall. He annihilated frontrunner Joop Zoetemelk in the 45-mile (72km) race against the clock, to take yellow by nearly four minutes. Two days later Hinault was crowned in Paris.

The Frenchman went on to dominate the world of cycling for eight years. In that time he would win another four Tour titles, two Vuelta crowns and three Giri, becoming the first rider in history to win all three *grand tours* more than once. He was an equal force in one day racing as well, winning the world championships, Paris–Roubaix, and both the Tour of Lombardy and Liège–Bastogne–Liège twice. His second win at Liège was one of most memorable in the race's history.

The race began amid snow and freezing temperatures. After only an hour, half the field had packed it in. Braving some of the toughest conditions ever faced in a bike race, Hinault survived the perilously icy roads to finish in Liège in a little over seven hours. Only 21 riders finished the race. Hinault's team-mates had watched aghast at the performance of their leader. So numbed had Hinault been by the cold that it took him weeks to recover. It is said that he still has no feeling in one of his fingers.

47

The first Tour de France starts
(1 July 1903)

Founded after the falling-out of Pierre Giffard, editor of *Vélo*, and Albert de Dion, a prominent backer of the paper, saw de Dion set about establishing his own rival publication, *L'Auto-Vélo* was first published in 1900, famously on yellow newsprint and with one Henri Desgrange as its editor.

Vélo and *L'Auto-Vélo* went head-to-head in the battle for the French sports-news-reading public. In January 1903 Giffard won a legal battle to have the word '*Vélo*' removed from his competitor's title, but his success was short-lived. On 16 January 1903 the first edition of the newly named *L'Auto* hit the news-stands and just three days later it ran a front page that would change the face of cycling: 'The Tour de France,' it announced, 'the greatest cycle race in the world.'

Initially a six-stage race was designed, starting and finishing in Paris, calling in on Lyons, Marseilles, Toulouse, Bordeaux and Nantes. It was to start on 31 May. Many felt the race was ridiculous, including most of the riders of the day. The race start was put back a month, rest days were included, entrance fees halved, prize money increased, daily expenses paid. On the afternoon of 1 July, 60 riders assembled in Paris at a café called Au Réveil Matin for the start of the first Tour. Only 21 would make it back. Maurice Garin held the lead for the entire race.

'I have dreamed many sporting dreams in my life but never have I conceived of anything as worthy as this reality,' wrote Henri Desgrange after the final stage.

Cycling would never be the same again. *L'Auto* would flourish on the back of its new race. *Vélo*, meanwhile, ceased publication a year later.

48

Eugène Christophe snaps forks on the Tourmalet
(9 July 1913)

Eugène Christophe never won the Tour de France but he is one of the race's most renowned riders because of the events of 9 July 1913.

The day started in Bayonne and finished in Luchon: 203 miles (326km) over four of the most terrible passes in the Pyrenees – the Aubisque, Tourmalet, Aspin and Peyresourde. Christophe was second in the overall standings heading into the stage and the day began well for him when the race leader, Odile Defraye, started to fall behind. Defraye had lost over an hour after the climb of the Aubisque, giving Christophe the virtual lead. Defraye finally abandoned at Barèges, halfway up the Tourmalet. By then, though, Christophe's day had taken a significant turn for the worse.

Having topped the Tourmalet just behind Philippe Thys, Christophe noticed a problem with his bike. What happened next has entered Tour legend.

Christophe watched his forks fold under him. 'I didn't crash,' he told *Sport et Vie* some 47 years later. 'I had time to see my forks bend before me.' With little option Christophe shouldered his machine and set off down the mountain on foot. Eventually, after walking 7 miles (12km), he made it to Sainte-Marie-de-Campan. There he was directed to a forge where he set about repairing his bike, refusing all help from the blacksmith, such assistance being against race rules.

With his bike repaired, Christophe set off again, bound for Luchon.

He made it to the finish line three hours and 50 minutes after stage winner Philippe Thys had crossed it. Incredibly, Christophe was not last on the stage. That dubious honour went to Henry Fontaine and Celidonio Morini who came in together more than seven hours down.

Christophe had lost the Tour but his tale of broken forks and village forges had secured his spot in Tour history.

49

Merckx is punched by a fan
(11 July 1975)

'The best there ever was. The best there ever will be.' That is the inscription engraved beneath a statue in Chicago of the incomparable basketball player Michael Jordan. In the world of cycling it applies equally to Eddy Merckx. No rider, before or since, has ruled the cycling world to the same extent.

It isn't just the sheer number of race wins that sets Merckx apart in the pantheon of cycling greats. It is the quality and prestige of the races that he won. A total of 11 Grand Tours, 19 Monuments and three professional world championships. He is the only rider to have won every Grand Tour and every Monument. He is the only rider to have won both the Tour and the Giro five times. He is the only rider to have won every Monument more than once. He holds the record for Tour stage wins (34), days in yellow (96), and days in pink (78). He holds the record for most world championship wins, although he shares that one with Alfredo Binda, Rik Van Steenbergen and Oscar Freire. And he could have won even more.

In 1975 Merckx was leading the Tour when, on the climb to Puy de Dôme, a fan broke from the masses at the roadside and punched the Belgian in the kidneys, striking out against the Cannibal's continued dominance. Merckx, winded and all but prostrate in pain, somehow managed to finish and keep yellow by just under a minute.

But the effect was long-lasting. Still suffering, Merckx lost the jersey to Thévenet on the next stage and finished second in Paris. While he would win a further stage at the Tour in 1977, he would never wear yellow again.

50

Tom Simpson falls on Ventoux
(13 July 1967)

In 1967 Britain's Tom Simpson headed to the Tour with hope in his heart but a weight on his shoulders. Among the world's greatest cyclists, he had won a clutch of classics as well as the world championships. At the Tour, though, things hadn't quite worked out. He'd worn yellow for one day in 1962 – the first British rider to do so, appearing in the next day's papers wearing the jersey and a bowler hat, holding an umbrella and sipping tea – on his way to finishing sixth in Paris, but so far that had been as good as it had got for Simpson at the world's greatest race.

In 1967 Simpson was lying seventh going into the stage over the Ventoux. In infernal heat he found himself on the early slopes of the climb in a group with the yellow jersey, Roger Pingeon, chasing Julio Jiménez and Raymond Poulidor, who were up the road.

With under 2 miles (3km) to go Simpson slowed dramatically and fell to the ground. The crowds picked him up and helped him back on to the bike. Simpson, riding in a daze, carried on for another 330 yards (300m) before collapsing again. Something was very, very wrong.

The Tour's doctor performed heart massage and gave the fallen cyclist an injection. He worked on Simpson for over an hour. Finally, a helicopter took him to hospital but Simpson was pronounced dead on arrival. The cause of death was cardiac arrest. Evidence of amphetamine was found in his bloodstream. 'A decent chap who probably simply feared defeat,' wrote Jacques Goddet.

Today a monument to the rider stands on the Ventoux near the spot where Simpson fell. Cyclists pass and leave small offerings – bidons or caps – to the man known simply as Mr Tom.

51

Bartali rampages through the Alps and saves a nation
(15 July 1948)

The day before stage 13 of the 1948 Tour was the race's third rest day. Sitting at the top of the classification was the darling of France, Louison Bobet. Italy's own legend, Gino Bartali, was more than 21 minutes down, even if he did have three stage wins to his name.

Over the border in Italy revolution was in the air. Bartali's homeland was in chaos. On 14 July the popular leader of the Communist Party, Palmiro Togliatti, was shot. Within hours, with Togliatti fighting for his life, strikes and demonstrations were called. Togliatti's supporters soon occupied key facilities. Alcide De Gasperi, Italy's prime minister, was in dire need of something to prevent the country slipping into violence so he called Bartali and told him he could make a difference; his country desperately needed him to win.

The next day, 15 July, Bartali answered his nation's call in emphatic style. From Cannes to Briançon, 170 miles (274km) over the Allos, Vars and Izoard, Bartali put on a one-man show. Bobet was left standing 18 minutes behind.

The next day the two went head-to-head. Bobet, fearing for his jersey, matched the Italian pedal stroke for pedal stroke over the Lauteret, Galibier and Croix de Fer. Finally, though, the Italian proved too strong. On the Col de Porte, Bartali powered away as Bobet cracked. He won his second straight stage to rip the yellow jersey from Bobet's back.

The French press lamented Bobet's fall. In Italy De Gasperi was delighted. As Bartali had stormed through France so his countrymen had stopped their own rampaging and turned on their wirelesses. Instead of revolution, celebration was in the air. Bartali had won his second Tour and brought Italy back from the brink of civil war.

52

First high mountain stage of the Tour de France
(21 July 1910)

The man responsible for inflicting the high mountains of France on
a hitherto unsuspecting peloton was not the father of the Tour, Henri
Desgrange, but his assistant at L'Auto, Alphonse Steinès, who proposed
they head into the Pyrenees.

Now Desgrange liked his riders to suffer but even he thought the
idea mad. Steinès set out to prove him wrong. He went south and set
out to drive over the Col du Tourmalet. Starting from Sainte-Marie-
de-Campan, 2.5 miles (4km) from the top he found the road was
blocked by snow. With darkness falling, Steinès left his driver to tackle
the climb on foot. His driver, justly concerned, alerted L'Auto's local
correspondent who set out with a search party. Eventually they found
Steinès on the brink of hypothermia. Once he had recovered, he sent
a telegram to Desgrange that read simply: 'Crossed Tourmalet. Stop.
Very Good Road. Stop. Perfectly Passable. Stop.'

And so it was that the 1910 edition of the Tour included two stages in
the Pyrenees. While stage nine took the riders from Perpignan to Luchon
over the Portet d'Aspet, stage 10 brought four huge legend-making
passes that would soon become known as le cercle de la mort – the
circle of death. Peyresourde. Aspin. Tourmalet. Aubisque. Four names to
strike fear into even the strongest of riders. At the top of the Tourmalet,
Octave Lapize had a lead of 550 yards (500m) over Gustave
Garrigou and plenty of time on everyone else. Hours later riders started
to appear at the top of the Aubisque. When Lapize arrived he looked
at Steines and uttered a single word: 'Assassins'. It was a moment that
would enter Tour legend. Lapize would go on to win but the stars of the
1910 Tour were the mountains.

53

Armstrong stands on the top step in Paris
(25 July 1999)

Lance Armstrong had only completed two three-week races when he took to the start line of the 1999 Tour. In 1995 he finished twenty-sixth in Paris. Then, in 1998, he came fourth in the Vuelta. In between those two performances he had been diagnosed with, and treated for, cancer. Now the man who had nearly died was back on his bike.

On 25 July, after three weeks of racing through France, Armstrong rode into Paris in yellow. He had won all three time trials and a mountain stage to Sestriere. As he stood on that Paris podium for the first time no one could quite believe what they had seen. Less than 18 months earlier Armstrong, having had to fight for his life, was struggling to get a cycling team interested in taking him on. Eventually US Postal signed him. Now he had delivered them the ultimate prize. It was the greatest comeback in all of sport. He would win the Tour six more times.

Doubts were raised early. How could Armstrong be clean yet dominate in what was known to be a drug-riddled era? The Texan dismissed the doubters and was aggressive in his defence.

Then, in 2012, everything crashed down around him. USADA (the United States Anti-Doping Agency) brought charges against him and others, including alleged use, possession and trafficking of prohibited substances including EPO, testosterone and blood transfusion. In August 2012 USADA imposed a lifetime ban and disqualified all Armstrong's results including his Tour wins. Armstrong remarked: 'Everyone I competed against knows who won those seven Tours.'

In January 2013 Armstrong finally confessed. He told Oprah Winfrey that the greatest story in sport, the story that had started on 25 July 1999, was all a lie. 'It's just this mythic perfect story, and it wasn't true,' he admitted.

54

Wiggins crowns an unforgettable season
(1 August 2012)

Hampton Court, London. Bradley Wiggins sits on a throne. His British Cycling jersey is unzipped, revealing a tattooed chest; his fingers and hands cast in 'V for Victory' formation; his adoring public bow before him, some of them wearing paper cut-outs of his trademark sideburns. After being anointed as the winner of the Tour de France just 10 days earlier, Wiggins now sits in the grounds of King Henry VIII's former palace as British cycling royalty.

Wiggins had just blasted around the 27-mile (44km) Olympic time-trial course. He had destroyed the competition. Silver-medal winner Tony Martin, the reigning world champion in the race of truth, was more than 40 seconds back. It was Wiggins's seventh Olympic medal. He was the toast of the capital. That win brought to a close a staggering year for the man born in Ghent, Belgium to a British mother and Australian father. In July 2012 Wiggins had become the first British rider to win the Tour. It came after an historic Paris–Nice, Romandie, Dauphiné treble. Only cycling legends Eddy Merckx and Jacques Anquetil had won Paris–Nice and the Dauphiné in the same year, but neither had won Romandie as well. In the summer of 2012 no one in the cycling world could touch Wiggins.

But it wasn't until the 2009 Tour and his surprise fourth place that he emerged as a real contender, and if his 2010 and 2011 seasons were ultimately disappointing and affected by crashes and injuries, 2012 made up for it in spades. 'I don't think my sporting career will ever top this now. That's it. It will never, never get better than that. Incredible,' said King Bradley as he sat on his throne.

But it did get better. Four years later Wiggins claimed his eighth Olympic medal, winning the team pursuit in Rio.

55

Alfredo Binda, first pro world champion, is born
(11 August 1902)

Throughout the late 1920s and the early 1930s, Italy's Alfredo Binda ruled the cycling world, winning the Giro five times and world championships three times in a spectacular career. Add four Tours of Lombardy, a couple of Milan–Sanremos and four national road race titles and you have a rider who dominated Italian cycling for more than eight years.

Binda, born in Cittiglio, near Varese, but raised across the French border in Nice, first came to notice in the 1924 Tour of Lombardy. He finished fourth but had climbed the Ghisallo alone at the head of the race and mixed it with Italian cycling royalty in the closing kilometres.

In 1925 he rode his first Giro, winning nearly five minutes ahead of Constante Girardengo. Binda was only 22, Girardengo 10 years older. It was to be the passing of the torch.

Described by René Vietto as having such a smooth style that he could cycle with a cup of milk on his back and it would remain full, Binda would win the Giro again in 1927, 1928, 1929 and 1933. His five titles remain a record, now shared with Fausto Coppi and Eddy Merckx.

He could have had even more Giro titles. In 1930, now with four wins under his belt, the Giro organisers were fearful that yet another Binda victory would dilute the public's interest in the race, and so paid the great man to stay away, giving him the same amount of money as he would have received had he won.

As he rode primarily for Italian teams, Binda's focus was always the Giro, hence he rode the Tour only once, in 1930. He won two stages in the Pyrenees and then abandoned. He would return to the race as a team manager, claiming wins with both Gino Bartali and Coppi.

56

Laurent Fignon, le Prof, is born
(12 August 1960)

With a blond ponytail, headband and round, rimless glasses, Laurent Fignon cut a somewhat unorthodox figure in the professional peloton of the 1980s and early 1990s.

Born in Paris, as a boy Fignon first used his bike to cycle to his beloved football training sessions. Discovering he was a good deal quicker than his friends, he joined the cycling club La Pédale de Combs-la-Ville and very soon became the rider to beat on the local scene.

At 18 he enrolled at the Université Paris XIII in Villetaneuse only to drop out to do his military service and continue cycling. It was this partial university education that, coupled with his glasses, led to him being nicknamed the Professor.

His first yellow jersey was a little tainted, coming in 1983 because of the abandonment of Pascal Simon who had captured the hearts of France by riding for six days with a broken shoulder. Fignon won the penultimate stage and entered Paris the winner by over four minutes.

He repeated the win in 1984, destroying his former team-mate Bernard Hinault, who had left Renault for the new La Vie Claire team.

Injury cruelly robbed Fignon of some of his prime years and, despite wins in classics, including Milan–Sanremo, it wasn't until 1989 that he returned to form at the Tour.

In 2010 his autobiography, *Nous étions jeunes et insouciants* – We Were Young and Carefree – was published. 'Sometimes when I was physically at my best,' he wrote, 'I could sense moments of utter ecstasy, those rare fleeting times when you are in total harmony with yourself and the elements around you: nature, the noise of the wind, the smells.' In the same year, he died from stomach cancer, aged just 50.

57

Victoria Pendleton wins first Olympic gold
(19 August 2008)

Britain's greatest female track sprinter, Victoria Pendleton won her first Olympic gold in 2008 at the Beijing Games. Already a six-time world champion, having claimed the individual sprint rainbow jersey in 2005, 2007 and 2008, the team sprint in 2007 and 2008, and keirin in 2007, Pendleton entered the 2008 Games as the world's premier female speed machine.

Queen Vic was dominant throughout. She set an Olympic record in qualifying before sailing through the first round, quarter-finals and semis to set up a meeting with Australia's Anna Meares in the final.

Meares, whose own appearance in the final crowned a remarkable comeback from injury, having eight months earlier fractured two vertebrae, was no match for the Briton, who needed only two of three races to win gold.

Pendleton would add to her Olympic haul in 2012. After suffering disappointment in the team sprint, when along with Jessica Varnish she was disqualified for an illegal changeover at the semi-final stage, she claimed gold in the keirin ahead of China's Guo Shuang. Pendleton hit the front at the bell and hung on to take the win by a wheel. She added silver in the sprint when Meares finally got her revenge, reversing the 2008 result.

By then Pendleton had added another three sprint world titles. She retired as Britain's most decorated female Olympian.

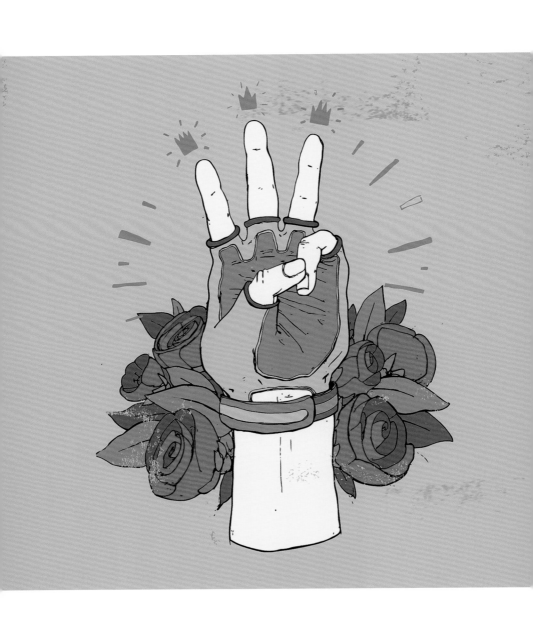

58

Merckx completes first triple crown of cycling
(25 August 1974)

It's the final 330 yards (300m) of the 1974 world championship road race in Montreal. Eddy Merckx is on the wheel of Raymond Poulidor. Merckx tightens his toe straps and readies himself. Poulidor glances nervously about him. The sprint is on.

Poulidor leads but Merckx lifts his backside out of the saddle and draws level. He briefly sits, gazes across at his opponent, lifts his backside again and is gone. 'Merckx is Merckx,' says Poulidor later. 'I had no chance against him.'

It was a historical win. That year he had also taken home both the pink and yellow jerseys, and now he'd added the rainbow. It was the first time a rider had won all three in a single season. Merckx had won the first triple crown of cycling.

Merckx's world championship story had started a decade earlier in Sallanches, France when, aged 19 he became the amateur world champion.

Merckx nearly hadn't ridden that race at all. When subjected to medical tests prior to selection, he had been told that he had a problem with his heart and wouldn't be considered for a place on the team. His mother, Jenny, didn't believe it.

Thanks to her intervention, Merckx got to ride and he repaid his mother in spades, soloing to a win 27 seconds ahead of a bunch sprint led in by fellow Belgian Willy Planckaert. Merckx turned professional the following year and set to ruling the sport for the next decade.

59

Maria Canins wins world TTT title
(27 August 1988)

When Maria Canins started cycling seriously she was 32 years old and a champion cross-country skier. Nicknamed the Flying Housewife, Canins, who in her ski career had amassed 15 national titles, took her first national cycling championships in 1982. It was to be the first of six national road race wins.

Canins was a seriously talented rider. The stamina she had so successfully built up on snow served her well on the roads of Europe. In 1985 she won the Tour of Norway before heading to France and the Tour de France Féminine. She won six stages, five of them in the

mountains, and won the overall by over 22 minutes from Jeannie Longo. The next year she successfully defended both titles.

In 1988 Canins won the inaugural Giro Donne by just over two minutes, taking the stage five time trial on the way. It had been an incredible haul of wins in little more than five years as a cyclist, especially given how late she came to the sport. But one thing missing was a rainbow jersey. She had come close with two second places but the top spot had so far eluded her.

On 27 August 1988, Canins rectified that. In Renaix, Belgium, in a 36-mile (54km) team time trial (TTT), Canins and her three Italian team-mates took world championship gold. Canins was particularly strong in the closing kilometres. 'Veteran Canins pulls the girls,' read the headline in *La Stampa*. Now the national champion was a champion of the world. She retired from cycling competition in 1995, an incredible 25 years after she won her first Italian championship as a cross-country skier.

60

Ian Steel wins first Tour of Britain
(1 September 1951)

The first Tour of Britain took place in 1951, a time of dispute between British cycling's governing bodies.

The National Cycle Union (NCU) had banned road racing in the late 1800s but Percy Stallard, who had raced on the Continent in the 1930s, introduced mass-start road racing to Britain in the 1940s. The NCU banned Stallard and any rider riding his races, so he set up a rival organisation – the British League of Racing Cyclists (BLRC).

It was the BLRC who organised the first Tour of Britain (though Stallard was no longer involved with the organisation). Starting on 19 August, the 14-stage, 1,400-mile (2,250km) event started and finished in London, going via Plymouth in the south and Glasgow in the north. Forty-nine riders started, attracted by the prize purse of some £1,000 on offer from sponsor the *Daily Express*.

The first stage finished in Brighton and was won by a French rider, Gabriel Audemard. Audemard attacked on East Dean Hill and gained a gap that he just held on to as the race reached Brighton. Delayed by a closed level crossing *en route* Audemard ran over a footbridge. Reportedly he was later given a 30-second penalty for allowing a member of the public to carry his bike over the bridge for him.

Scotland's Ian Steel won the race. He claimed three stages in total and took the race lead in his home town of Glasgow. He held the yellow jersey for the rest of race, recording an overall winning margin of more than six minutes. 'It's been great fun,' he said.

Steel would go on to win the Peace Race in 1952, the only rider from Britain to have done so.

61

Lucien Buysse is born
(11 September 1892)

Belgium's Lucien Buysse turned professional in 1914 after winning the 1913 amateur Tour of Belgium. His professional career interrupted in its infancy by the First World War, he returned to the sport in 1919 and set about forging a name for himself.

Good performances in some one-day classics, including podium finishes in Paris–Roubaix, Liège–Bastogne–Liège and Bordeaux–Paris, and fourth in the 1921 Giro, led to some great rides in the Tour, where he sealed his reputation as a tough, gritty rider.

The 1926 edition of the Tour remains the longest in history: 3,570 miles (5,745km) over 17 stages. It was on stage 10 that Buysse took yellow. It was a day that would go down in Tour legend.

At 201 miles (323km), the stage was by no means the longest that year, but going over the Aubisque, Tourmalet, Aspin and Peyresourde it was certainly the toughest. And to make things worse the day brought horrendous weather: with a cutting wind, torrential rain and ice forming on the mountain tops, the dirt roads became nothing more than trails of mud. Thunder roared and lightning danced around the peaks of the Pyrenees as Buysse made his move. He had long marked this stage as the crucial one. And he had already suffered far worse. Early in the race his daughter had died but his family had urged him to continue. Bad weather wasn't about to stall his march.

Buysse attacked early and led over the Aubisque. He rose over the Aspin and Peyresourde in glorious isolation and rolled into Luchon more than 25 minutes ahead of the next rider. Behind Buysse it was carnage. Only 54 riders made it to Luchon. *L'Auto* described it as a day of inestimable suffering. Buysse, though, was in yellow. And he'd keep it until Paris to record the best result of his career.

62

Alto del Angliru makes its Vuelta entrance
(12 September 1999)

Stage eight of the 1999 Vuelta a España was 109 miles (175km). It started in Léon and finished at the top of a new climb. While never tackled by the Vuelta before, it was about to become perhaps its most feared climb.

Then known only as La Gamonal, its inclusion came at the suggestion of Miguel Prieto, the communications director for the charity ONCE, which sponsored a cycling team in the 1990s. He had discovered the mountain in 1996 and wrote to the Vuelta's then race director, Enrique Franco, recommending he check out the climb, saying it could become the Vuelta's Mortirolo (the legendary Giro climb). Franco was sold on it. In 1998 the race announced that the next edition would feature a new summit finish, to be known as the Alto del Angliru.

It was a name that would soon strike fear into the hearts and legs of every Vuelta rider. The final 4 miles (6.5km) average more than 13.5 per cent gradient, with stretches over 23 per cent. The hardest section comes just 2 miles (3km) from the top, at Cueña les Cabres. It is here that the climb is at its steepest, and where, when the Vuelta visits, the crowds flock. Thousands block the road, a continuous wave of fans, parting only at the last second to leave a tiny corridor of noise through which the riders can grind.

That first visit in 1999 was won by José Maria Jiménez. The Spaniard, riding for Banesto, launched his bid for the stage win 2.5 miles (4km) from the top. He caught Russia's Pavel Tonkov, outsprinting him on the line to win. At the time of writing there have been only six summit finishes on the Angliru. But, due to its severity (it was once called an inhumane climb by the Spanish rider Oscar Sevilla), it has become one of cycling's most infamous mountains.

63

Eddy Merckx wins his last road race
(17 September 1977)

It is unlikely that anybody lining the road in Ruien, Belgium, on 17 September 1977 was aware that they were about to witness cycling history. But witness it they did, for on that day those watching the Kluisbergen Criterium were the last people ever to watch the great Eddy Merckx cross the finishing line of a professional road race in first place.

Merckx enjoyed a remarkable professional career that lasted 14 years. He rode for seven different teams, amassing a staggering tally of 525 race wins. The 1977 Kluisbergen Criterium would turn out to be the last of those wins.

Earlier that year Merckx had entered the Tour de France with hopes of claiming a sixth victory. He suffered with illness but remained in touch as the race hit the Alps in the final week. Then, on the Col du Glandon, he was left to suffer by the younger generation. As they sped away to the stage finish at l'Alpe d'Huez, Merckx was engaged in his own battle, against the mountain and against time. 'Eddy has perhaps wanted to ride one Tour too many,' said the *Dauphiné Libéré*.

But Merckx was a fighter. He was awarded the stage win the next day at Saint-Étienne after crossing the line in third spot when the first- and second-placed riders were disqualified and he went on to finish sixth in Paris.

Merckx's time at the top of the sport was coming to an end. His final road win at Kluisbergen, a sprint ahead of compatriot Marc Demeyer, was in a race that had never before invited professionals. The townspeople paid to see the great Merckx win and they went home happy. Merckx announced his retirement in the spring of 1978, nine months after that last road win, calling it the most painful decision of his career. The Cannibal had finally left the peloton.

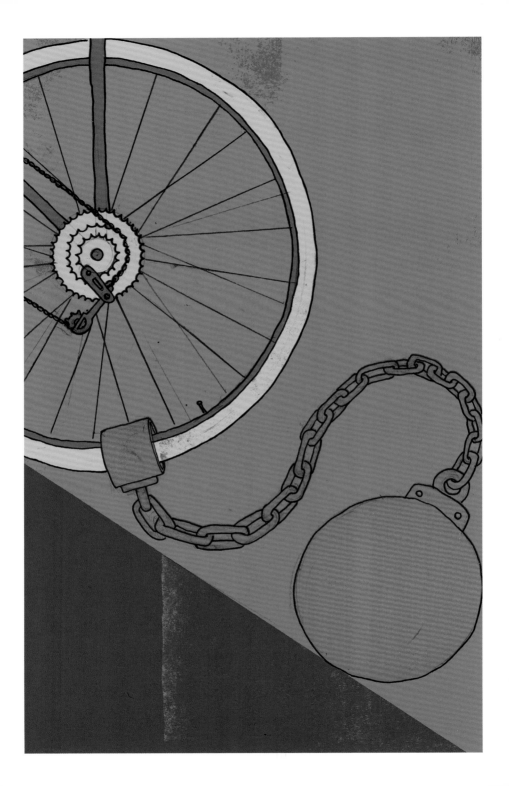

64

L'Equipe's 'worst Tour climber ever' is born
(30 September 1982)

At the 2009 Tour this writer was standing on the side of the Col du Petit Saint Bernard. I stood and cheered as the leaders passed. I applauded as the various groups of trailing riders followed, hauling themselves up the mountain. Then ... silence. I craned my neck down the road – no more cyclists to be seen. The crowd began to disperse, fans started cycling back down the mountain. But the broom wagon hadn't been through. There must be one more rider on the road.

There was. Kenny van Hummel.

Van Hummel had become accustomed to riding up mountains alone. Last into Saint-Girons, last into Tarbes, last into Verbier. Today he would be last into Bourg-St-Maurice. His combined deficit to the winners of those four stages? Over two and a half hours. The following day *L'Equipe* would run a story in which Jean-François Pécheux, a director on the Tour, described van Hummel as the worst climber in Tour history.

'I'll quit when I fall off my bike,' van Hummel said.

Unfortunately for van Hummel, and for cycling romantics everywhere, that is exactly what happened the next day. Dropped with less than 3 miles (5km) of a 106-mile (170km) mountain stage completed, van Hummel was descending quickly off the category one Col des Saises, trying to regain time, when he crashed. He was taken to hospital and was forced to abandon. 'It's the end of a big adventure,' said his *directeur sportif* Rudi Kemna.

Van Hummel retired from the sport at the end of the 2014 season.

65

Marianne Vos wins her first rainbow jersey
(1 October 2004)

Vos was born in 1987 in the southern Netherlands city of 's-Hertogenbosch. First attracted to cycling after watching her brother in action, she started riding a bike at the age of six. By eight she was racing and winning.

At the 2004 junior worlds Vos showed her intentions within the opening kilometre. She attacked from the off but was quickly reeled back in – a little leg-warmer and teaser for what was about to come. On the final lap, everything changed. Vos escaped on the climb of the Torricelle with 6 miles (10km) to go. Soon she had over 20 seconds. That was enough. She won by nearly 30 seconds. It was her first rainbow jersey and it would be by no means her last.

That 17-year-old Vos, loaded with potential then, is now widely regarded as the finest cyclist of her generation. The only rider who stands comparison with her is Eddy Merckx and she shares his nickname of the Cannibal. Vos has won everything worth winning. At the time of writing she has 12 elite world titles to her name across road, track and cyclo-cross and two Olympic gold medals. She has won the world cup overall a record five times, the prestigious Flèche Wallonne a record five times and the Giro three times.

She is the most dominant rider of her generation. Of any generation, in fact. When not ruling the roads in summer, she is mastering the cyclo-cross mud of winter. So far her wins number more than 300 and rising. Fast.

66

Jeannie Longo-Ciprelli wins a fifth road race rainbow jersey
(7 October 1995)

When France's Jeannie Longo-Ciprelli took to the start line of the women's world championship on 7 October 1995 she was 37 years old and looking to make history.

For six long years, Longo-Ciprelli had shared the record for most world championship road race wins. Along with Belgium's Yvonne Reynders, who took her wins in the 1950s and 1960s, Longo-Ciprelli had four wins. She wanted a fifth. She wanted to sit at the top of the tree alone.

The race didn't start well for her: she crashed on the second of five laps. In intense pain she continued (at the end of the race she would require stitches in an inch-wide gash in her leg). Finally she made it back to the leading group with two laps to go, broke away with team-mate Catherine Marsal and then, on the final climb, attacked and rode away and into the record books.

Fast-forward over 20 years and Longo-Ciprelli is still riding. She has had a career rare in both longevity and success. Her first national road title came in 1979, her most recent in 2011. That's a 32-year gap. In total she has claimed the national road race title 20 times, the national time-trial title 11. As well as a five-time road race world champion, she is a four-time time-trial world champion. All those tallies are records. Add in track titles and Longo-Ciprelli has a staggering 59 national and 13 world titles to her name. And Olympic gold. And she won the Tour de France Feminine three times. That's a record as well.

67

André Mahé dies
(19 October 2010)

Born in Paris in November 1919, for 10 years from the mid-1940s André Mahé was a professional cyclist. Something of a journeyman, he rode for seven different teams throughout his career (11 if you include regional teams assembled for the Tour), picking up just a handful of wins. But it is for one of those wins that he is remembered today.

It is 17 April 1949. Late afternoon. The velodrome in Roubaix is packed with expectant fans waiting to see the finale of the forty-seventh edition of the Paris–Roubaix classic. Three riders are approaching the velodrome: Mahé, Jesus-Jacques Moujica and Frans Leenen. They have minutes on everyone else. The three get to the track but a race official sends them the wrong way. Instead of sprinting to the line they are now cycling around outside trying to get in. The race is slipping away. Moujica falls. Mahé and Leenen leave him. In confusion and desperation they try a door. They shoulder their bikes, go through the door and find themselves in the press tribune. The crowds, all peering expectantly at the usual entrance, are treated to the sight of professional bike racers climbing over seats trying to get down to the track. There they remount and sprint to the line. Mahé takes the sprint and is awarded a bizarre race win.

The next arrivals are led in by Serse Coppi, Fausto's brother. They enter the velodrome the usual way and Coppi wins the sprint. Due to Mahé's diversion, Coppi then claims he is the first rider to have actually completed the race route. And so starts months of wrangling. In November 1949 a compromise is finally reached: both Coppi and Mahé are awarded the win.

68

Alex Zanardi is born
(23 October 1966)

In 2001 Italian racing driver Alessandro Zanardi suffered a huge crash during a CART series race at Lausitz, Germany. Returning to the track after a pit stop, Zanardi spun into the path of oncoming cars travelling at full race speed. He was struck by Alex Tagliani, the impact demolishing the front of his car. Zanardi's heart stopped seven times. He was given the last rites, but he survived, though he lost both legs.

Zanardi later reflected that as a racing driver he used to think about how he would react in the event of a life-changing accident, wondering

how he would cope. When his worst fears came true he knew. 'I had a clear perception that I had cheated death,' he later told CNN. 'I was very happy, and full of joy at being alive.'

In 2009 he took up handcycling, initially competing in marathons. His first major medal came in 2011 when he took silver in the T4 time trial at the world championships.

Zanardi made the Italian team for the London 2012 Paralympic Games, where he won two golds, claiming the H4 individual time trial and the H4 road race. He celebrated by holding his wheelchair aloft. 'I've had a magical adventure and this is a fantastic conclusion,' he said.

More world titles followed in 2013 and 2014 but perhaps his greatest achievement came in September 2014 when he completed the Ironman world championships in Hawaii alongside able-bodied athletes. Zanardi finished inside the top 300 of more than 2,000 competitors in this incredibly tough event.

69

Sarah Storey is born
(26 October 1977)

Dame Sarah Storey (née Bailey) is one of Britain's greatest athletes. Born without a properly formed left hand as a result of her arm being caught in the umbilical cord in the womb, Storey has dominated the para-sport scene across three decades and two sports.

Storey's first sport was swimming and she excelled at it. Determined one day to represent her country after watching the Los Angeles Olympic Games as a six-year-old, she not only trained relentlessly but repeatedly and doggedly pressed the authorities for invitations to trials. Her talent, focus and determination ensured she would not be overlooked. Storey took part in her first Paralympic Games at Barcelona in 1992 at the age of 14 and won five medals, two of them gold. She followed that with more golds at Atlanta and silvers at Sydney and Athens.

In 2005, still competing in the pool, Storey suffered a severe ear infection, which kept her out of the water for months. In order to maintain her fitness she took to the bike. It was to transform her career. By the end of the year Storey had claimed the para-cycling world record for the 3000m individual pursuit. A future on wheels beckoned.

Her first major competition on the bike was the 2005 European championships and she returned with a case full of medals – three golds and a silver. Since her switch to cycling Storey has ridden at two more Paralympic Games, claiming another six medals, all gold.

Such is her talent that she often competes and wins in able-bodied competitions. In 2010 she represented England in the Commonwealth Games and she has also won gold medals in world cup team pursuit races as well as claiming a number of national titles on the track.

70

Le Baron Rouge is born

(4 November 1960)

Nicknamed *le Baron Rouge*, Frenchman Eric Barone holds the world record for the fastest speed ever recorded on a bicycle. Barone holds two records for speeds set on a prototype bike on both snow and gravel. Markus Stöckl holds the records for speeds on both surfaces set using a serial production bike.

Barone, a former stuntman, set his first speed record in 1994 when he recorded 94.18mph (151.57kph) at the Alpine ski resort of Les Arcs. One year later he went an incredible 26mph (42kph) faster and 12 months on again he reached 124mph (200kph). By now his equipment was far more sophisticated. In less than four years he had gone from essentially being a man in a ski-suit on a mountain bike to resembling a superhero perched on a machine with looks more in common with a F1 car than the humble bike.

In 2000 Barone returned to Les Arcs. There he bettered his previous mark, reaching 138.08mph (222.22kph). He set the record for speed on gravel 18 months later on the Cerro Negro volcano in Nicaragua where he reached 107.29mph (172.661 kph). His 2000 record stood for 15 years. Then Barone entered the Vars Speed Challenge in the French Alps.

The sun shone down on the perfect Vars piste on the morning of 28 March 2015. But it was windy. Ignoring the buffeting flags that would hit his back, the *Baron Rouge*, clad in his trademark red speed-suit, was helped on to his bike which was perched precipitously above a steep 1.7 mile (2.7km) long track, carefully carved from the perfect snow.

With a simple 'three, two, one, go!', he was off. And at speed. The *Baron Rouge* had hurtled through the speed trap at 138.75mph (223.3kph), beating his previous mark by just over 0.6 miles (1km) an hour. Now 55, Eric Barone continues in his quest for speed.

71

Cofidis trial begins in Paris
(6 November 2006)

An investigation into doping that had started in 2004 at the French Cofidis team finally reached its conclusion in a criminal trial that began in Paris on 6 November 2006.

Ten people associated with the team were facing charges. A technician, pharmacist and *soigneur* were charged with supplying drugs while seven cyclists were accused of acquiring and possessing banned substances.

Among the cyclists was Britain's David Millar. Millar had already confessed to using the banned drug EPO after his apartment was raided in 2004. By the time of the trial he had already served a two-year ban from the sport and had returned to the peloton with the Spanish team Saunier-Duval a committed anti-doping campaigner.

Millar testified to the culture at the Cofidis team, describing it as one of 'get results and do what you have to do' to win. Two months after the end of the five-day trial the sentences were announced. Millar was acquitted, the other cyclists received suspended sentences.

Millar went on to ride for a further eight seasons, becoming a rider for, and part-owner of, the Garmin team. During his comeback he was vociferous about driving doping from the sport. His reaction during a 2007 Tour de France rest-day press conference when news broke that Alexandre Vinokourov had tested positive will live long in the memory. 'If a guy of his class has done that then we may as well pack our bags and go home,' he said.

A year on from the Cofidis trial it seemed nothing had really changed. 'Nobody is trying hard enough,' Millar said.

72

Léon Houa is born
(8 November 1867)

Born in Liège, Belgium, Léon Houa won the first three editions of the one-day classic Liège–Bastogne–Liège.

Known as *la Doyenne*, the Old Lady, Liège–Bastogne–Liège is the oldest major classic still raced today and one of the five most important one-day races of the season. The first edition took place in 1892, organised by the Liège Cyclists Union. It was for amateurs only and 33 riders started out from Liège shortly before 5.40 a.m. on the morning of 29 May for the 155 mile (250km) race.

Léon Lhoest, who had won the amateur national championships two years earlier, was the favourite. Soon there were three riders at the head of the race: Lhoest, Houa and Louis Rasquinet. When Lhoest got a puncture, Houa told his coach, who was following, to pass him his bike. It was an act of huge generosity. But then Lhoest punctured again. They had not yet ridden halfway.

Houa rode alone for the rest of the race. He crashed 6 miles (10km) from the finish, breaking a pedal, and so was forced to finish the race pedalling with just one leg. Lhoest finished second, 22 minutes down.

Houa returned to win again in 1893. In 1894 he turned professional. That year *la Doyenne* was opened to professional riders for the first time. Houa again entered and again won. Later that year he won Belgium's first professional national championships.

La Doyenne grew into one of the most important races on the cycling calendar. Eddy Merckx holds the record for most wins, claiming five victories between 1969 and 1975.

73

The Red Devil wins Lombardia
(12 November 1905)

Nicknamed the Red Devil for his favoured scarlet jersey, Giovanni Gerbi had a rather cunning approach to winning races. In 1905 he won the inaugural Tour of Lombardy, 143 miles (230km) starting and finishing in Milan. Gerbi had done his homework. He knew the route intimately. He knew the roads were in a bad way and that his route knowledge could gain him a huge advantage.

Accounts vary as to the precise details of what followed, but in his book *La Fabuleuse Histoire des Grandes Classiques et des Championnats du Monde* (1979), Pierre Chany tells us that Gerbi discovered a section early in the race where the road narrowed to a point through which only one rider at a time could squeeze. Gerbi faked abandoning shortly before the road narrowed, leaving the bunch to ride headlong into the impassable section. A pile-up was all but guaranteed, leaving the wily Gerbi to pick his way through the carnage and ride alone to victory while everyone else sorted themselves out.

And so Gerbi came to ride the final 124 miles (199km) of the inaugural Tour of Lombardy alone. While his initial break may have had much to do with his cunning, the rest was down to his legs. By the time he powered into Milan his lead had grown to over 40 minutes.

In 1907 Gerbi would again cross the finish line of Lombardy in first place after employing a little cunning, this time involving locked level-crossing gates, tacks and nails, and pacing from training buddies. But the organisers had grown tired of Gerbi's 'tactics' and he was disqualified.

74

British League of Racing Cyclists is formed
(14 November 1942)

With the relatively new invention of the bicycle being viewed with suspicion by the upper classes in Britain, in 1890 the National Cycling Union (NCU) banned road racing on bicycles. It would be more than 60 years before officially sanctioned road races were re-established.

An underground movement emerged. Time trials were organised discreetly by the Road Racing Council (today known as the CTT, Cycling Time Trials) and run under the cover of near darkness, with riders wearing black and no race numbers. Eventually the NCU came to accept there was little it could do to prevent time trials on open roads. Officially sanctioned official events soon followed.

Mass-start road races remained banned, however, but the NCU was continuously lobbied by Percy Stallard, a road-racing enthusiast who had competed in the amateur world championships in 1934, to open themselves to mass-start road racing.

With the NCU standing firm, Stallard took matters into his own hands and organised races himself. The result was that the NCU suspended any riders competing in road races. A battle had commenced. Stallard formed the Midland League of Racing Cyclists which was quickly joined by similar organisations in Yorkshire and London. On 14 November 1942 the British League of Racing Cyclists (BLRC) was formed. The NCU tried to get the new organisation banned but to no effect. Twelve months later 30 clubs were being run under the BLRC. It was hugely successful. In 1944 it organised the first stage race in Britain – the Southern Grand Prix.

In 1959 the NCU and the BLRC finally merged to become the British Cycling Federation.

75

Fabio Parra, Colombian cyclist, is born
(22 November 1959)

In 1988, Fabio Parra became the first South American to stand on the podium at the Tour de France, when he finished third in Paris.

Parra was born in Sogamoso, Colombia, in 1959. Colombians had been riding in the Tour since 1975 with Luis 'Lucho' Herrera becoming its first stage winner in 1984 when he won at l'Alpe d'Huez. Not a bad place to record your country's first stage win.

In 1985 Parra entered the fray in what was a terrific year for the Colombians. Riding for the Café de Colombia team, both Herrera and Parra lit up the Tour. First Herrera took a stage win at Avoriaz, beating

Bernard Hinault in a two-man escape. Then the pair rode into Lans-en-Vercours together at the head of the race, this time Parra taking the win. Two days later Herrera won again. In Paris, he wore the polka-dot jersey of the King of the Mountains and Parra was crowned the race's best-placed young rider.

Parra rode again in 1986 but was forced to abandon on stage four. The following year he finished sixth but it was in 1988, now riding for Kelme, that he made history.

He won the stage into Morzine, escaping alone with 12 miles (20km) to go, but it was the next day that saw him rise into the top three. It was a long day in the saddle, 141 miles (227km) over the Madeleine, Glandon and up to l'Alpe d'Huez. Parra finished fourth, just 23 seconds down on stage winner Steven Rooks; it was enough to take him into third. He slipped to fourth briefly but rose again in the Pyrenees and by Paris he was firmly ensconced in third place, becoming the first Colombian to stand on the Tour's final podium. It remained the best performance by any South American until Nairo Quintana finished second in 2013.

76

Six days of New York finishes
(25 November 1939)

Six-day racing was first held at Madison Square Garden, New York, in 1891. At first riders raced alone, with the only limit to the amount of time they could ride being stamina and their ability to go without sleep.

By 1899 the format of the race had changed. With concern growing for the wellbeing of riders who, only too aware of the financial rewards on offer, were now pushing themselves beyond all reasonable levels of endurance, a rule was introduced by the New York legislature stating that no individual could ride for more than 12 hours a day. The ruling led to teams of two being formed and in 1899 the Garden hosted New York's first two-man six-day race.

Into the 1900s and the event grew in popularity. Soon six-day races were springing up in other American cities. Six-day riders were among the most famous and best-paid athletes in the US. Demand grew so much so that from 1920 New York hosted more than one race a year, attracting the celebrities of the day to the Garden to watch the action. In 1925 it was the first event to be hosted in the rebuilt Garden which had been designed with the requirements of six-day racing in mind.

The last six-day meet in New York prior to the Second World War took place in 1939. Started by baseball star Joe DiMaggio, the race finished on 25 November with Cesare Moretti and Cecil Yates winning. Six-day racing returned to New York in 1948, but not at the Garden. It wouldn't be until 1961 that the event, dubbed by at least one writer the 'Mad Whirl', returned to its spiritual home. At the time it was hoped that it would be the first of many but any such optimism soon faded and the 1961 edition proved to be the last of the New York Sixes.

77

Marshall 'Major' Taylor, the Black Cyclone, is born

(26 November 1878)

Heralded by Lance Armstrong as the greatest American cyclist in history, Marshall Taylor was an African American who blazed a trail around the world, winning countless bike races while fighting racial prejudice. At his peak he was considered the fastest cyclist in the world, earning him the moniker the Black Cyclone.

Born in 1878, Taylor was just two generations from slavery, his grandfather having been a slave in Kentucky. He was befriended by a wealthy white family who employed his father and it was they who gave him his first bicycle, on which he delivered papers and learned tricks. A local shop-keeper spotted Taylor and set him to work performing tricks outside his shop dressed in military uniform. Thereafter, life would never be the same for 'Major' Taylor.

By his teenage years he was winning races and setting records. Before he was 20 he had turned professional and is today recognised as the first African American athlete to have received commercial sponsorship. In 1899 he became a world champion.

For years he dominated track racing but he suffered appalling racial abuse, having to fight prejudice virtually everywhere he went – and this at a time when the League of American Wheelmen had also voted to bar black members.

Taylor retired in 1910. Bad investments meant that he lost his fortune and was reduced to selling his self-penned, self-published autobiography door-to-door. He died in 1932, broke and anonymous, and was buried in a pauper's grave. In 1948, when his fate became known, his body was reburied and a memorial service held in his honour.

78

Patrick Sercu wins his first six-day race
(28 November 1965)

The greatest six-day racer of them all, Belgium's Patrick Sercu, won his first six-day title in November 1965, when he won the Ghent Six, partnering Eddy Merckx, beating Peter Post and Tom Simpson by 68 points.

Sercu was already an Olympic and amateur world champion on the track by the time of this win, so he was hardly an unknown. Riding with his friend, the soon-to-be all-conquering Merckx, the pair were unstoppable. An 18-year professional career followed, during which time Sercu rode 233 six-day races, winning 88 of them and claiming the records for most six-day wins at Ghent, Frankfurt, Dortmund and London.

Sercu was the major attraction at the winter Sixes for well over a decade but he was far from just a track racer. In the spring and summer he competed on the road and won there as well. In fact, he would rightly be considered to have had a very successful racing career even if he had never turned a pedal on the track, such is the scale of his achievements on the road: six stage wins and the points jersey at the Tour; 13 stage wins at the Giro; stage wins at Romandie, Paris–Nice and the Criterium du Dauphiné; wins at Kuurne–Brussels–Kuurne and Kampioenschap van Vlaanderen; and an armful of top-ten finishes in a number of Classics. 'As an athlete you set goals and you achieve and then you move on like a journey,' he once said in an interview with *British Cycling*.

Sercu retired in 1983. In 2014 he was awarded the Order of Merit by the Belgian Olympic Committee.

79

Christa Rothenburger-Luding is born
(4 December 1959)

Germany's Christa Rothenburger-Luding made history in 1988 when she added silver in the match sprint at the Olympic Games in Seoul to the speed-skating gold and silver medals she had won seven months earlier at the Calgary Olympic Winter Games. It was the first time any athlete had won medals at both the winter and summer Olympic Games in the same year.

Rothenburger-Luding was a supremely talented speed-skater, who claimed world records as well as multiple Olympic medals in the sport. She had only started cycling as a way of keeping fit during skating's off-season.

Realising she was a more-than-capable track sprinter, she entered the 1986 world championships in Colorado Springs, USA. She made it to the final of the sprint where she won the rainbow jersey ahead of Estonian Erika Salumäe, who was riding for the Soviet Union.

Two years later Rothenburger-Luding was on skates in Calgary. There she took a silver and a gold in the 500m and 1,000m speed-skating events. She set world records in both, only for her 500m mark to be broken by gold medal winner Bonnie Blair minutes later. By contrast her 1,000m record stood for nine years.

Later that year she was back in Olympic competition. This time on the bike. In Seoul the world championship result of 1986 was reversed: Salumäe took gold, Rothenburger-Luding silver. But it was the East German who entered the record books as the only athlete to have won medals at a winter and summer Olympic Games in the same year.

The winter Games were later moved so that they no longer fall in the same year as the summer Games, meaning that her feat can no longer be repeated.

80

Tommy Godwin sets Year Record
(31 December 1939)

Before dawn on 1 January 1939, Tommy Godwin, a 26-year-old cyclist who had been born in Stoke-on-Trent in 1912, got on his bike and started riding. For the next 12 months he would barely stop.

The challenge had been established as far back as 1911 when *Cycling* magazine started a competition to see how many 100-mile (160km) rides a cyclist could complete in a year. The competition soon morphed into the number of miles ridden in a year. Marcel Planes was the first holder with 34,666 miles (55,789km). His record stood for over 20 years but throughout the 1930s it fell again and again. By the time Godwin started his attempt the mark to beat was an incredible 62,657 miles (100,193km), held by Ossie Nicholson. That's nearly eight times the diameter of the world as measured at the equator.

On 26 October 1939 Godwin rode into London's Trafalgar Square, the new record holder. But still he kept going. By midnight on 31 December he had 75,065 miles (120.805km) under his wheels, and had smashed the previous record, averaged 205 miles (330km) in a day. He took only one day off from riding the entire year.

But it was not enough. Onwards Godwin cycled. On 14 May 1940 he finally stopped, having reached his new target of beating the previous record for 100,000 miles (160.930km) by over a month. A few weeks later Godwin signed up with the RAF and went to war.

Godwin's Year Record stood until early 2016. It had long been considered unbreakable until America's Kurt Searvogel finally made the breakthrough, recording 76,076 miles (122,432km) in January 2016. That final mileage total was no accident – Godwin's record had stood for just over 76 years.

GLOSSARY

Abandon – the quitting of a rider during the race, either through injury, mechanical problems or exhaustion.

Arrivée – the finish line of a road race.

Bidon – a plastic water bottle that is clipped to the frame. They used to be made of tin and carried in cages that were fixed to the handlebars.

BLRC – the British League of Racing Cyclists, founded in 1942 to promote mass-start road racing in Britain, at the time banned by the National Cycling Union.

BMX racing – a mass-start sprint race held on a custom-built, off-road course featuring jumps and banked turns. Up to eight riders compete in the same race.

Boards – a colloquial term for the track in a velodrome. Tracks are oval in shape and feature high, banked corners. UCI regulations state they must be between 145 yards (133m) and 547 yards (500m) in length, however Olympic and World Championship races must be held on a 273-yard (250m) long track.

Break / breakaway – a rider, or group of riders, that breaks free from the front of the main bunch. Often teams will assess the riders in the break to see if they should

try to prevent the break getting away or whether they can let them go as they pose no threat to their own leaders (also see Teamwork).

Broom wagon – the vehicle that follows a road race to collect any riders that abandon the race. *Voiture-balai* in French.

Classics – a collective term for the most prestigious one-day road races. Most have been included on the cycling calendar for decades. See also Monuments.

Clenbuterol – a drug that is used to treat asthma but also promotes muscle growth and burns fat. Its use is prohibited by WADA.

Criterium – a multiple-lap race held on a short circuit, normally in a town or city centre. Historically held in northern Europe. Successful professional riders would negotiate large contracts to appear in criterium races, boosting attendance for organisers. It remains a popular form of racing.

Cyclo-cross – a form of bike racing that takes place over multiple laps of an off-road course featuring sharp climbs over a variety of terrain including mud and sand. Successful cyclo-cross racers need strong running skills as well as great bike handling as they are forced to carry

bikes on their shoulders and run when riding becomes impossible. Races are most commonly held in the winter.

Départ – the start line of a road race or stage.

Derny – a small motorbike used for pacing cyclists.

Directeur sportif – the head coach of a cycling team.

Domestique – French for servant, these are the real heroes of road racing. They spend their days looking after the leaders on their team, fetching water, ferrying food and chasing breaks. This is the reality of life as a professional road cyclist for the majority of riders. See also Teamwork.

EPO – Erythropoietin, or EPO is a hormone produced naturally in the body that controls red blood cell production. Red blood cells deliver oxygen to the muscles and the more red blood cells, the more oxygen delivered, resulting in increased stamina. EPO can be produced artificially and injected in order to boost red blood cell production and therefore enhance athletic performance.

Espoir – French for hope, in cycling terminology an Espoir is an under-23 rider, specifically one aged 19 –22 years.

Festina affair – the doping investigation sparked by the discovery of a large amount of performance-enhancing drugs in a car allocated to the Festina team prior to the 1998 Tour de France. The discovery exposed the extent of doping in cycling, particularly the use of EPO, and threw the race into chaos.

Flamme rouge – the red flag that hangs at the start of the final kilometre of a road race, advising riders there remains only 1,094 yards (1,000m) left to the finish.

General Classification (GC) – the overall standings in a stage race. The leader of the GC at any one time wears the leader's jersey. The rider at the top of the GC after the final stage wins the overall race.

Grand départ – the overall start of a stage race.

Grand Tours – a collective term for the three most prestigious stage races: the Tour de France, Giro d'Italia and Vuelta a España. They are the only stage races that run for three weeks.

Grimpeur – a rider who specialises in riding uphill.

Indépendant - a category of rider no longer in use. An *indépendant* was a semi-professional rider who could ride against both professionals and amateurs. While they had not signed professional terms, unlike amateurs they were able to accept payments from sponsors and race for money.

Jerseys – special jerseys are awarded to classification leaders in a stage race. The classifications featured can vary race to race but will always include the GC leader and normally also include a sprinters and a climbers classification. Jersey colours also vary race to race; famous examples include the leader of the Tour de France, who wears a yellow jersey, and the leader of the Giro d'Italia, who wears pink. World champions win a white jersey with rainbow-coloured stripes printed on it. They wear the rainbow jersey throughout the season in races where they are the world champion in that discipline.

Keirin – a paced track race. Normally around 1.25-miles (2km) in distance, riders follow a derny which gradually increases the pace before peeling away with around a third of the race to go, leaving the riders to sprint for the win. Its origins lie in Japan.

Kermesse – a multiple-lap race held in Belgium on a closed-road circuit. Similar to a Criterium but often smaller and held as part of a wider celebration – a village fair, for example.

Madison – a team track event, usually ridden in pairs. Only one rider races at a time, the other switches in only when their partner touches them, normally by way of a hand-sling. There is no limit to how long each rider spends racing. The winning team is the one which gains the most laps. Points are also awarded in intermediate sprints and are used in the result of a tie.

Monuments – the collective term for the five most important and most prestigious one-day Classics. They are: Milan–Sanremo, Tour of Flanders, Paris–Roubaix, Liège–Bastogne–Liège and the Tour of Lombardy.

Mountain-bike racing – held off-road on courses that can feature testing climbs, descents and obstacles, mountain-bike races are split into various types including cross-country, downhill, endurance and marathon. Cross-country is the only form so far to be included in the Olympic programme.

Mountain classifications – climbs that feature on the route of a road race are often classified. Classifications range from Category Four (least testing) through to *Hors Categorie* (beyond classification). The main factors determining the classification awarded to a climb are its length and gradient although where it appears on the route (i.e. near the start or finish) can also be an influence.

NCU – the National Cycling Union, or NCU, oversaw track and circuit racing in Great Britain from 1883. It merged with the British League of Racing Cyclists (see BLRC) in 1959 to form the British Cycling Federation.

Omnium – a multi-discipline track cycling event comprising six races: a scratch race, an individual pursuit, an elimination race, a time trial, a flying lap and a points race. Points are awarded in each race with the rider with the largest tally at the end of the six races declared the winner. The event entered the Olympic programme in 2012.

Pacing – the practice of riding in the slipstream of an out-rider, or pacer, in order to conserve energy. Pacers most commonly use small motorcycles although riders on tandems and even cars have also been used. While the keirin is the most obvious example of a paced race today, in the past paced road races were commonplace, particularly those that took place over vast distances.

Palmarès – the record of results a rider achieves throughout their career.

Parcours – the route of a road race.

Patron – the boss of the bunch. While not a formal appointment, the patron of the peloton is the most respected rider and the one who is listened to most in the inner-workings of a professional peloton.

Pavé – the cobblestone roads that feature in some one-day classics.

Peloton – the main bunch of riders in a race. Can also be used generally as a collective term for professional road cyclists – e.g. the peloton was not happy with the latest change to the cycle-race calendar.

Prime – an in-race prize awarded to the first rider to pass that point of the race.

Pursuit – a track race where two individuals or teams race against the clock, starting on opposite sides of the track. The aim is to complete the race distance in the quickest time. If one catches the other before the end of the race distance they are declared the winner. Teams comprise four riders with the time taken on the third rider across the finish line.

RAAM – the Race Across America. A 3,000-mile (4,828km) race from California to Maryland run as one continual stage. Racers can compete either individually or in teams.

Race classifications – the UCI classify races according to the type of race (1= one day race, 2= a stage race) and its importance or difficulty. The highest classification of road races is the World Tour, which includes all three Grand Tours and all the major one-day classics as well as races such as the Critérium du Dauphiné and Tour of Switzerland. So the Tour de France is classified as 2.UWT. In women's road cycling the highest classification is the World Cup (CDM). Away from the road the Olympic Games and world championships are the highest categorised races.

Race of truth – a colloquial term for a time trial – just one person riding against the clock with no team-mates on hand to assist and nowhere to hide.

Randonné – an organised long-distance bicycle ride which is not raced but where times may be recorded.

Rider types – cyclists fall into different categories depending on their speciality. Some road riders are good climbers but aren't as fast as others over a 220 yard (200m) sprint. On the track some riders can sustain a high power output for minutes at a time but don't have the burst of acceleration needed for the sprint events. It often comes down to physiology. The type of body needed to ride to the summit of a 6,600 ft- (200m-) high mountain three or four times in a single stage is very different to the one needed to contest a mass sprint at the end of a 124-mile (200km) flat race. See also *Grimpeur*, *Rouleur* and Sprinter.

Road racing – races held on closed roads. They may take the form of a single mass-start race where the winner is the first to cross the finish line; a race held over stages (see GC; or a time trial (see separate entry). Courses can vary from multiple laps of a circuit or run from one town to another and can be designed to feature certain terrain designed to suit a particular type of rider and therefore encourage exciting racing. See Rider Types.

Rouleur – a good all-round rider who doesn't fall into the category of a good climber or sprinter. Often working as a *domestique*, a *rouleur* is someone who can spend hours at the front of a race driving the pace. Their best chance of a win normally comes from a joining a small escape group and working with the others to keep their advantage intact until the finish line.

Six-day races – a track meeting that lasts for six days. Initially riders rode individually with the winner the rider who completed most laps. The only limit to how long riders spent on the track was their own stamina. Over the years, with the wellbeing of riders paramount, the format has changed. Today racing usually starts in the early evening and lasts for six or seven hours, taking in a variety of disciplines with points awarded for each as well as for gaining laps and winning intermediate sprints and in the all-important Madison races (see separate entry). The winning pair is the one which has accumulated the most points at the end of the meet.

Soigneur – the person who cares for a rider throughout a race. Such care will include the giving of massages and the handing out of food during a race.

Sprinter – a type of rider who has the turn of speed needed to excel in the final mass-dash to the line of a road race, or in the match sprint and keirin on the track.

Teamwork – while race wins may be awarded to individuals, cycling, particularly road racing, is a team sport. Teams will designate one or two riders as their leaders for a race and the rest of the team will work for those leaders. That 'work' will include the chasing and marshalling of any breaks that may go, pacing leaders back to the bunch in the event of a mechanical problem, sheltering their leader from the wind, and the fetching and carrying of food and drink. The aim of the team is to deliver their leader into the final moments of the race in as fresh a state as possible, giving them the best opportunity to win.

Time limit (*hors-délai*) – all riders are expected to finish a road race within a certain percentage of the winning time. The percentage varies depending on the race course (hilly or flat, long or short). If a rider finishes outside of the time limit imposed by the organisers they are thrown off the race.

Time trials – a timed race ridden either individually or in teams. Large differences in times can appear over comparatively short distances, meaning those with eyes on winning races that include time-trial stages need to be good riding alone against the clock.

Track racing – races that are held on a track within a velodrome, either inside or outside. Track racing comprises speed and endurance events ridden both individually and in teams. See also Boards, Keirin, Omnium, Pursuit.

UCI – cycling's governing body – stands for the Union Cycliste Internationale, or International Cycling Union.

UVF – France's national cycling federation. Stands for the Union Vélocipédique de France. It later became the FFC – La Fédération française de cyclisme.

WADA – the World Anti-Doping Agency. Established in 1999 as an independent agency to bring consistency to anti-doping regulations and policies. Its foundation board includes representatives of the International Olympic Committee, National Olympic Committees, Sports Federations, athletes and international governments.

ACKNOWLEDGEMENTS

A note of thanks...

This book would not have been possible without the support and assistance of a number of people. We'd like to take this opportunity to thank all at Aurum Press who have worked on this project – specifically Robin Harvie, who was instrumental in shaping the book before departing for pastures new, and Jennifer Barr and Lucy Warburton who have expertly guided both of us through the entire process and have had a huge part in the book you now hold in your hands.

We owe a debt of gratitude to everybody at *Boneshaker Magazine*. It was through that wonderful publication that we first worked together and their unique blend of quality writing and great design remains an inspiration. They have always been happy to offer us advice when asked, something for which we are enormously grateful.

We would like to thank our respective families and friends for all of their interest and support – and for their understanding when we disappeared from daily life for months on end (only to be distracted, and with thoughts often elsewhere, when we did occasionally emerge). Special thanks go to Edwin Cruden for the title.

Finally, but most importantly, we would like to thank our wonderful partners who supported us immeasurably throughout the whole experience with enthusiasm and encouragement. Without them this book simply would not exist. Karen and Julia – to both of you, from both of us, thank you.

Giles and Dan, May 2015

BIBLIOGRAPHY

This book draws on a wide range of sources, far too many to list here, but the following are worthy of special mention:

Belbin, Giles, *Mountain Kings: Agony and euphoria on the peaks of the Tour de France*, Punk Publishing, 2013.

Cazenueve, Thierry, Court, Philippe and Perret, Yves, (eds), *Les Alpes et Le Tour*, Le Dauphiné Libéré Hors-Serie, 2009.

Chany, Pierre and Cazeneuve, Thierry, *La Fabuleuse Histoire du Tour de France*, Minerva, 2003.

Chany, Pierre, *La Fabuleuse Histoire des Classiques et des Championnats du Monde*, Editions ODI, 1979.

— *La Fabuleuse Histoire du Cyclisme*, Editions ODIL, 1975.

Cossins, Peter, *The Monuments: The Grit and the Glory of Cycling's Greatest One-day Races*, Bloomsbury Publishing Plc, 2014

Howard, Paul, *Sex, Lies and Handlebar Tape: The Remarkable Life of Jacques Anquetil*, Mainstream Publishing, 2011.

McGann, Bill and McGann, Carol, *The Story of the Giro d'Italia*, Vol. 1 & 2, McGann Publishing, 2011.

Millar, David, *Racing Through the Dark*, Orion Books, 2011.

Rendell, Matt, *Blazing Saddles*, Quercus, 2007.

Sykes, Herbie, *Maglia Rosa*, Rouleur Books, Bloomsbury Publishing Plc, 2013.

The Official Tour de France Centennial 1903-2003, Weidenfeld and Nicolson-Orion Publishing Group, 2003

Woodland, Les, *The Yellow Jersey Companion to the Tour de France*, Yellow Jersey Press, Random House, 2003.

In addition to the above, the archives and back-issues of the following publications were of particular assistance: The Official Reports of the Olympic Games, *La Stampa*, *Le Petit Journal*, *Le Petit Parisien*, *Le Journal de Genève*, *Rouleur*, *Procycling* and *Miroir-Sport*, as well as those of the *Guardian* and the *Telegraph*.